THE END OF
ZIONISM
and the
Liberation of the Jewish People

edited by

EIBIE WEIZFELD

CLARITY

Cataloging in Publication Data:

The End of Zionism and the liberation of the Jewish people

Includes bibliographical references.
ISBN 0-932863-08-6

1. Zionism. 2. Jews--Politics and government.
3. Jewish nationalism. I. Weizfeld, eibie, 1948-

DS149.E63 1990 320.5'4'095694 C90-090104-7

In-House editor: Diana G. Collier

CLARITY PRESS, INC.
Suite 469, 3277 Roswell Rd. N.E.
Atlanta, GA. 30305, USA

and

CLARITY INTERNATIONAL
P.O. Box 3144
Windsor, Ont. N8N 2M3, Canada

TABLE OF CONTENTS

ACKNOWLEDGMENTS

Clarity Press would like to thank the following publishers for permission to reprint the materials herein:

for Reb Moshe Schonfeld, from *The Holocaust Victims Accuse:*
Neturei Karta of U.S.A.
G.P.O.B. 2143
Brooklyn, N.Y. 11202

for Youri Andréev, from *Zionism: Propaganda and Reality:*
Novosti Press
7, rue Bolchaia-Potchtovaia
Moscow 107082, U.S.S.R.

for Maxime Rodinson, "Nation and Ideology" from *Cult, Ghetto and State:*
Saqi Books
26 Westbourne Grove
London W2 5RH, England

for Lenni Brenner, from *The Iron Wall:*
Zed Books
57 Caledonian Road
London N1 9BU, England

for Albert Memmi, from *Jews and Arabs:*
J. Philip O'Hara, Inc.
2858 Valerie Ct.
Merrick, N.Y. 11566

for Noam Chomsky, from *Peace in the Middle East?*
Pantheon Books
201 East 50th St.
New York, N.Y. 10022

FOREWORD

Having had my say from time to time in various forums, I have been inclined to let the situation remain as is, ie. a situation of permanent war between the Israelis and the Palestinians with the likelihood of further degeneration into violence and hatred. This passive nihilist attitude is not adopted by will, but is rather a consequence of the hostility engendered by criticizing the Zionist dictatorship over the Jewish people, the lack of even one single opportunity to debate the matter with any Zionist representative, the lack of resources to present an alternative view to Zionism within the Jewish community, my subsequent political isolation, and my dedication to the movement against the preparations for nuclear war.

What then motivates me to continue with this struggle is that the Middle East conflict, as it is called, has become a theatre for the possible use of nuclear weaponry, not due to a threat from the Soviet Union, but rather due to the threat posed by the State of Israel. As reported by the imprisoned Jewish technician Mordachai Vennunu, the Israeli arsenal includes up to 200 nuclear devices ready to be assembled into bombs and capable of being delivered by intermediate-range missiles called Jericho as in the Torah story. This threat presumably is meant to prevent or retaliate against an intervention by the Soviet Union which would be under pressure to intervene against a possible invasion by the U.S.A. in the event that Israel were to be under duress from the Palestinians and their allies.

The Palestinian response to twenty years of "temporary" occupation has been that of a permanent revolution until victory, the only possible alternative. Now, after a year of public agitation and official repression, the struggle continues and is soon to become a civil war. Amongst the Jews of "Israel" there are already 160 Israelis who have refused to obey their officers' orders to serve in the "occupied territories" and are consequently in prison. Further escalation of Israeli repression into the massacre which is slowly taking place now will result in increasing casualties amongst the Israeli soldiers and settlers. Jewish actions in solidarity with the Palestinians will be treated, more so, as subversive activities, and the civil war will spill over into the Jewish community. Jewish soldiers who will not tolerate the fascist tendencies of both the major Israeli political blocs, Likud

and Labour, will plan a coup d'état, and collaborate with the indigenous Palestinian forces to prevent further massacres, as the fascists utilize the conflict to force further expulsions. Already the first Jew (Emile Greinswig) has been killed by a grenade thrown at a "Peace Now" demonstration outside then Prime Minister Begin's home where the cabinet was meeting after the Sabra-Shatila massacre in Beirut, Lebanon, conducted by General Sharon.

This is surely an intense period which is to continue for a while yet, and is a consequence of the failure of the Israeli leadership to give sufficient consideration to the offer of peace proposed by the unified leadership of the Palestine Liberation Organization / Palestine National Council. The stubbornness of the Jewish People in their continuing support of the Israeli State is a consequence of the fact that the powers that be have not resolved the problem of the existence of the Jewish People, and would seem to be incapable of doing so.

I must add that my reluctance to engage in such strenuous conflict has been overcome not only by the pressure of events, but also by the gentle pressure of the publisher, Clarity International, and in particular, Mrs. Annette Gordon, who have impressed me with the necessity of this work.

eibie Weizfeld, 1990

INTRODUCTION

The long and tortuous course of events in the Middle East appears to be reaching an explosive and potentially final paradox: at the very time of what might appear to be the final consolidation of the Zionist state in Israel, with the achievement of PLO Leader Arafat's public recognition of the State of Israel's right to exist, and the dispersal of organized PLO guerrilla forces in Lebanon, we are witness to an immense mass groundswelling of resistance to Israeli occupation in the tenacious and bloody Palestinian *intifadah*. As the major Israeli parties seem incapable either of bringing the *intifadah* to an end by force, or of providing fresh and acceptable policy options for achieving peace with the Palestinian people, and as the publicity given the *intifadah* continues to eat away at Zionist support worldwide, both within the Jewish community and outside, it is hardly surprising that a major review of the history and theoretical underpinnings of Zionism should be in order. The following anthology will doubtless be but one in a succession of many such critical undertakings, comprising Jewish and non-Jewish writers alike.

That such critiques might point towards the end of Zionism -- whether the Zionist State of Israel succeeds in quelling the present *intifadah* or not --should hardly be surprising, for even if the present *intifadah* is successfully suppressed, there can be no assurance that other uprisings will not take place in future. Given the declining birthrate of Jews in relation to Palestinians living in Israel which will take effect by the 21st century, either a new relationship between Jews and Palestinians must begin, or the Jewish nation must surrender its aspiration towards European-style democracy, and become more similar to South Africa, with a minority settler population dominating an indigenous majority by legal-constitutional structures and force. Despite the enforced influx of Soviet Jewry, the control exercised by Zionist parties over the Jewish population will likely be undermined by these non-Zionist Jews. Even if Zionism were to succeed in maintaining itself, the *intifadah* witnesses its absolute failure to bring about the amicable relations which would ensure the state of well-being, security and happiness of its Jewish inhabitants, let alone the Palestinians within Israel. What we are witness to, therefore, is the end of Zionism as a solution to the aspirations of the Jewish nation.

For North American students of contemporary Middle Eastern affairs, there can be little question that most material available in newspapers, libraries and journals until 1982 had been supportive of the Zionist cause. Since the 1982 invasion of Lebanon, however, and increasingly as the Palestinian *intifadah* continues, the public has received greater access to the anti-Zionist perspective of Palestinians and those who favor their cause. What still remains little known to the greater public is the current of anti-Zionist resistance and critique among Jews themselves.

Significantly, in assembling this anthology, editor Weizfeld has endeavored to provide Western readership with access to writers whose views are rarely available to them. The anti-Zionist critique is far from monolithic. As a sampling, herein included are the historical accusations raised by the Naturei Karta movement against the Zionist leadership in its willing and unnecessary sacrifices of Jewish blood to the Nazi holocaust in order to purchase western acquiescence to the Zionist program (*The Holocaust Victims Accuse)* as well as the theoretical objections raised by French former communist, Maxime Rodinson (*What is Zionism* and *Nation and Ideology).* The official Soviet line, reflected in *Zionism: Propaganda and Reality,* provides an historical materialist analysis of the historical underpinnings and ills of Zionism.

What makes this anthology unique, however, and distinguished from collections of writings critical of Zionism as a whole, is anthologist Weizfeld's refusal to submerge the historically proven longing of the Jewish people for territorial self-determination -- for the right to be themselves, to live as Jews, to have Jewish self-government -- in the equally legitimate rights and historically proven quest of the Palestinian people for the very same thing. Both have legitimacy. The needs of self-determination for both nationalities must be taken into account. While it may be the case that Zionism has perpetrated desperate ills against the Palestinian people (and against the Jewish people themselves) in pursuit of its goals, the solution, Weizfeld argues, is not the scourging of the legitimate aspirations of one people in favor of those of another.

Where the problem lies, as Weizfeld unerringly pinpoints, is in the mistaken view of the Zionist creation of a uni-national Jewish state on the territory of Palestine as being the only format for fulfillment of the legitimate demands for self-determination by the Jewish people or nation. Such a view, Weizfeld points out, has its historical roots in the (false) Western notion of the uni-national nation state, with its

patterns of ethnic dominance and submergence of other nationalities as minorities.

Today we live in a world order where the western concept of the supremacy of the supposedly "uni-national" (while in fact, multi-ethnic) nation state is breaking down. On the one hand, the nation is being superceded, in federations such as the European Economic Community. On the other hand, in the socialist bloc, nationalities are demanding and being given greater leave to self expression and government within the overall framework of the Soviet Union. And in numerous multi-nation states, nationalities submerged as minorities -- the African-Americans in the U.S., the Dalits in India, to name only a few -- are demanding varying degrees of self-determination. The rapid development of new legal constitutional structures to accommodate the needs and demands of dominant and submerged nationalities worldwide reflects the inadequacy of the Western uni-national state concept and forecasts its demise.

Why then, Weizfeld argues, should the "Jewish problem" be confined to such narrow modalities? Why not consider the rapidly expanding paradigms available in international law? Why not consider the relation of nationalities as was normative in oriental/Islamic territories prior to the incursion of western colonialism, where Jews lived in relative peace and harmony with their Arab brothers.

The debt owed to the Jewish People as a result of the fascist holocaust and their quiet collaborators cannot be resolved simply through cash payments to the few survivors of European Jewry. The eradication of fascism, including the removal of all collaborators, such as Kurt Waldheim, from positions of power, is a necessary precondition, together with the territorial solution of Jewish existence. That is, Weizfeld argues, there must be a territorial homeland for the Jews in those continents where the Jews are concentrated, upon land that is clearly undisputed and suitable. Guarantees for Jewish civil liberties in the urban settings as well must be established by national-cultural autonomy alongside the de-confessionalization of secular society away from the Christian churches. Together with the national-cultural autonomy of other national communities, the myth of national ethnic minorities must be abolished to recognize the international character of societies in general, and the equal freedoms and rights of each and every individual citizen.

It is for this reason -- that there are options other than the zero-sum alternative of Zionist Israel or its Palestinian counterpart for the just solution of the bloody conflict in the Middle East -- that this

anthology has received its dual title: *The End of Zionism and the Liberation of the Jewish People.* Zionism cannot survive -- not just because of its historical crimes against Arabs and Jews, and its regressive theoretical underpinning on the false and dated Western concept of the uni-national state -- but because it cannot bring peace and happiness even to those who by force of arms might continue to maintain a tenuous victory. As the *intifadah* continues, the quest for solutions can only become more intense. The contribution of this anthology, in its diversity and its overall focus, is invaluable. For it is in the interest of all that Zionism must end. And as Weizfeld convincingly argues, it is the first step towards the liberation of the Jews.

Diana G. Collier

REB MOSHE SCHONFELD
from *The Holocaust Victims Accuse*

{The ultra-orthodox (Chassidic) Jews in the article which follows present a highly principled denunciation of political Zionism and its instigators. It is only the "Neturei Karta" faction who express publicly the alienation felt by the traditional religious community towards the State of Israel.

It should be noted that in this contribution, repeated references are made to "the Jewish people" as a nationalistic concept, even though "Jewish nationalists and Zionists" are both grouped together as the opposite pole of attraction. However, a theistic nationalist reference is made to "the AlMighty's chosen nation." The contribution that this idealization makes to the Zionist ideology's blatant disregard of the indigenous Palestinian-Arab People is not considered, nor is there mention made of the Palestinians themselves. To do so would conflict with another point imbedded in this critique of Zionism, which is that Palestine is "our Holy Land," a point shared by Zionism as a chauvinist ideology.

Furthermore, although Jewish nationalists are here being associated directly with Zionists, it is done with some depreciation of the struggle against Zionism, since it gives credence to the Zionist claim to be the national liberation movement of all the Jewish People. In addition, such lack of a differentiation, while tending to present the religious opposition in a more attractive manner, fails to take into consideration the anti-Zionist revolutionary socialist movement "Di Yiddishe Bund" (The Jewish Union) organization, which was the majoritarian tendency in Warsaw ghetto politics. The Jewish Bund (Union) maintained both a nationalistic and anti-Zionist working people's position, and would have formed a natural principled ally of the traditionalists. The Bund, although non-religious, did not carry an anti-religious offensive, and in its current manifestation, The Jewish Workman's Circle Organization in North America, continues in this manner. It is this flaw of the Neturei Karta, rooted in sectarianism, which halted any further cooperation of these two movements, although this perspective piece mentions in self-criticism that this tendency "didn't come out strong enough against the Zionists." e.W.}

FOREWORD

At a national conference of Tzirei Agudas Yisroel (Youth of the Aguda) which took place during the establishment of the "State of Israel," the delegates came to one decision which aroused a furor even amongst factions of Agudas Yisroel, and "Hamodia" (Agudah Hebrew Daily newspaper) refused to publish it as a matter of principle. The controversial resolution stated: "We declare that, at this time of the establishment of the state, our beliefs of the past remain the same: Zionism constitutes a danger, spiritual and physical, to the existence of our people."

Last year, a new printing of the book, "Yaldei Teheran Maashimim" ("The Teheran Children Accuse") appeared. It was meant especially for Bnei Torah, and was distributed in yeshivos and kollelim. That frightening manuscript enumerates what the Zionist movement can do to the spirit of our people. The booklet which we are publishing here, "Serufay Ha Kivshonim Maashimim" ("The Holocaust Victims Accuse") serves as an attempt to show, by means of testimonies, documents and reports, how Zionism and its high-level organizations brought a catastrophe upon our people during the era of the Nazi holocaust. If the Yaidei Teheran affair serves as an example of the implications of "greater is the (sins of) one who causes another to sin than the (sins of) one who kills another", analogous to destroying the soul and leaving the body, then what the heads of the Zionist movement did to the European Jews during World War II cannot be defined except as the one who actually does the killing. "Serufay Ha Kivshonim Maashimim" is a collection of nine essays which were printed in "Digleinu" in the years 1961-64 under the heading "Ani Maashim -- Min HaMaitzar" ("I Accuse -- From the Depths"). The fruit of the pen of Reb Moshe Shonfeld, it constitutes a continuation of the revelations of the gaon and tzaddik, Rabbi Michael Ber Weissmandel, who devoted his life to saving his brothers, and endlessly alerted the Jewish world. But there was no one listening to him...

The reading material in the pamphlet before us is very bitter, but it is essential that we look into it and absorb it in order to know the secular enemy and to understand his character and nature.

The essays printed in the booklet include just a small part of a serious accusation, which exposes the leaders of Zionism as war criminals, who contributed their share to the destruction of six million of our people. In the archives of the Goodman Family in London, Eisz of Zurich, Sternbuch of Montreux and Griffel and Weissmandel in the United States, are hidden documents and reports which are

hair-raising and are waiting to be brought to light. Therefore, one must end the pamphlet with "finished, but not ended" in the hope that these matters will be completed. This is our obligation to millions of victims, as well as to clarify our consciousness and our world outlook. The Kotzker Rebbe said, "who increases knowledge, increases pain; even though he will add pain, a person must increase his knowledge."

The Zionist approach, that Jewish blood is the anointing oil needed for the wheels of the Zionist state, is not a thing of the past. It remains operable to this very day.

What occurred in recent months to 600 Jews from Russia, who left Yisroel for Belgium, is again an illustration of the Zionist principle that Jews only exist to serve as a footstool of the Zionist state, and they are only powder and cannon fodder for its establishment and the forging of its strength. Not in an organized fashion, but separately, these 140 families arrived in Belgium, including babies, children and the elderly. They arrived with practically nothing after first paying all their debts to the Jewish Agency. The rumors that they came under the sponsorship of the missionaries were designed to make them hated by the Jews outside of Eretz Yisroel.

As is the way of Jewish people, they first went to the Jewish relief organizations. It became clear to them that the pressure of the Jewish Agency had cut them off from any aid from relief organizations, both worldwide and local. Having no other choice, they turned to Christian organizations, which had nothing to do with the missionaries. They agreed to help them only after they became aware, to their great astonishment, that the Jewish organizations were withholding all aid. The Gentiles learned that, for the first time in history, Jews were hardening themselves against refugee brothers, abandoning them and their children to starvation, disease -- and to the mercy of the Gentiles.

The Orthodox Jews of Belgium hurried to help them, without considering that their concept of Judaism was nil, since they were innocents long under the rule of the atheistic Soviets. If not for this, who knows if the plans of the Zionists wouldn't have succeeded and 600 Jews, who did not cut off their ties to Judaism during 50 years of Communism, would have been forced to choose between mass suicide and accepting Christianity? Again it was reiterated where the love of Jews can be found: who nurtures it and who destroys it.

Since the existence of Zionism, one constant trend of thought has been the direction of Weizmann, Greenbaum, Sharett, Ben

Gurion, Ehrenpreisz, Kastner, Stephen Wise, the councils in the ghettoes and the rescue committees of the free world. The only yearning was for the State. The people as a whole, or a segment thereof, were merely the means for the realization of a "homeland". Whoever did not serve this purpose might as well have not been created.

INTRODUCTION

World War II began. The accursed German soldiers conquered Poland and most of the other nations of Europe quickly and seemingly, effortlessly.

After the fall of Poland, where the majority of European Jewry resided, Hitler immediately began to implement the "Final Solution": to slaughter and exterminate every Jewish soul. The murder of the Jews was no small affair to Hitler. It was his main goal and the very first item on his agenda.

Even up to the present time, there has been no one who can enable us to understand the psychology behind this ruthless mass murder of the Jews. Why did Hitler want this? Why did he put so much effort into it? Why did he kill men, women and children? Why did he destroy millions of able-bodied persons during an all-out conflict, when each one was capable of serving him through hard labor, which was so necessary for his war effort? What brought this evil and wicked man to his extermination plans and actions-- - and why did all the nations of the world laugh at us during this tragic period, which has so often been spoken of as an integral part of "modern civilization"?

Why did President Franklin Roosevelt jest about us while meeting with Stalin at Yalta, saying, "I want to sell you the six million Jews in the U.S.A."? Why did the White House hold back from the general public all news of the mass murders going on in the occupied countries? The American Government's representatives in Europe were also warned not to have anything to do with this whole situation, which didn't concern them. All the rescuers of dogs and cats were not active at the time and all the societies for the prevention of cruelty to animals did not anguish over the torture and mass annihilation of human beings.

The chronicle of all that happened to us in those days is very long; and what is known to us leaves a much larger amount unknown - - possibly never to be revealed.

The dreadful voices of the slaughtered in Auschwitz tore away at the Heavens, but they were isolated voices. They cried out from one end of the world to the other, but they were not heard.

Every day, thousands of Jews were transported to a place from whence they didn't return. They were tortured in every way, reaching such a state of numbness that after a while, they no longer even felt the pain. The Nazis viewed them as some sort of animals or other lowly creatures. No one remembered them or thought about them, and certainly no one took a public stand against the countless murders and exterminations in the fiery furnaces with such unfamiliar, but auspicious names as Treblinka, Bergen-Belsen, Maidanek, Dachau and Buchenwald. During those frightful years, all was quiet. No one cared. No one said a word.

It was astonishing, just looking at it, to see how millions of Jews were being killed in every way, and it was even more amazing to perceive how each and every one, with his eyes open, meekly took off his clothes and descended obediently into the pits of blood: how they did all that they were ordered to by the German murderers. Even seconds before they were shot, they unquestioningly complied with Nazi demands that they step into the very pits where others before them had just met their untimely and violent deaths.

But even the shadow of death in front of them did not have the strength to steal away from them the great merit of saying, "Shema Yisroel HaShem Elokainu HaShem Echod", with a clear mind and a pure heart. Their declarations of G-d's Oneness poured forth from their lips quietly, but ascended straight up to the Heavenly Throne. The most plain and simple Jew, totally bewildered by the events that led to his being murdered was, in the final analysis, persecuted only because he was a Jew. This is part of our holiness and loftiness as the Almighty's chosen nation. Our sanctification of His Name is enshrined forever and we would have it no other way.

The fact, however, that our people were brutally murdered by beastly agents of the Angel of Death in human form would be totally inexplicable to us, if it were not for the understanding were derive from our holy Torah that all of this was, indeed, from the Almighty. The rabbis in the Warsaw Ghetto counted for nought everything in the secular world and its seemingly awesome political and military events. Rather, they cited the curses, rebukes and punishments, as enumerated in the "toh-cha-chaw" in Parshas Bechukosai. The rabbis of Hungary, squeezed together in the cattle cars to Auschwitz, standing for long hours without food or drink, as much as 90 in a car, also saw the awesome fulfillment of these dire warnings in the Torah's

list of retributions; maintaining that it all happened to us because we didn't come out strong enough against the Zionists.

Rabbi Chaim Sonnenfeld, chief rabbi of the Orthodox community in the Holy Land, once had a poignant encounter with one of Palestine's leading Zionists. This deliberate opponent of Torah gloried in perpetrating wickedness against the sainted Rabbi Sonnenfeld. Encountering Rabbi Sonnenfeld as the latter left his house with head burried in his hands, after hearing of the untimely death of one of his beloved sons, who was then only 45 years of age, the wicked atheist approached Rabbi Sonnenfeld while he was walking with deep heartache along the streets of Old Jerusalem. "You are deserving this punishment," mocked the Zionist, "because you have made it your life purpose to fight against us". The grief - stricken Rabbi Sonnenfeld firmly replied, "On the contrary, I am being punished because I have not done enough to destroy your ways. I promise to oppose more vigorously your detrimental way of life."

What is this "Zionism" that can bring even potentially priestly Jews down to such depths? It is the desire to throw off the guide and the light of the Almighty and His holy Torah and to merely live like all other peoples. It means seizing our Holy Land and perverting its Divine purpose for the sake of having just another "land" like everyone else.

But even here, our prophets tried, several millenia ago, to transmit to us the Almighty's warning as to what would happen if we followed such a path. Ezekiel (20:32) prophesied: "If you say, 'let us be like all the nations of the world', 'as I live', vows the Almighty, 'if not with a strong hand and an outstretched arm, then with the full force of My wrath shall I reign over you'."

The great Rabbi Elchonon Wasserman said and wrote on this verse that no one can ascertain in which of the three epochs (strong hand, outstretched arm, full force of My wrath) we are now existing - - and who knows what will happen if we continue to disregard the instructions of the Almighty...

Shortly after this frightful warning, the most and the best of the Jewish people found themselves under the thumb of the accursed Hitler and his allies, the nations surrounding Germany. But the insane Jewish nationalists and Zionists stood up in their safe, convenient dwellings, especially the United States, laughed at Hitler and thereby incited him. In newspapers and at meetings, by making speeches and blowing shofar in front of the German consulate, they

stupidly antagonized the Nazi fuehrer. If this was not enough, they aroused his anger and hatred even more, and brought him entirely to the edge of madness, by calling for a boycott of German goods. In 1933, when all the nations were still at peace with this wicked man, Hitler; when there was no other way but to employ the tried and true method of using humbleness and soft words, these self- appointed Zionist leaders acted contrary to the dictates of wisdom and contrary to the oaths to which the Almighty had sworn the Jewish people in exile not to rebel amongst the nations. To a large extent, it was they, themselves, who drove this mad dog, Hitler, to the ultimate in insane meanderings and subsequently parallel actions.

Throughout history, the Jewish people were many times in danger of being exterminated, Heaven forbid. The axiom that "Esau hates Jacob" is reproven amidst out people in every generation with blood and tears. Everything possible to obliterate this unwritten law hasn't helped. Our enemies are constantly reminding us, but the Almighty has pity on His poor nation. He gave us righteous and truthful advocates and intercessors. They do what they have to do, and the merit of both the masses and their ancestors helps them.

In our generation, the Jewish people left this time-proven method that was accepted by our forefathers. We forgot the only way that we could survive and live in exile - - especially during difficult times. We forgot that the leaders of our people have to be believers in the Almighty and believers in the Torah. As Rabbi Michael Ber Weissmandel, ztl, writes in one of his letters, their fraudulent approach stood against them in making them ridicule and despise our traditional way of dealing in humbleness. They joked and made light of the Jew who tread gracefully and graciously in front of the ruling authorities. It was in this respectful way that almost all Jews used to exist. But because of those who mocked, and with their methods, they brought almost the entire Jewish people into the ways of nation-alism and Zionism, articulating demands rather than requests.

There is no doubt that the Almighty will take revenge for the blood of his servants. The spilled blood of the Jewish people will not be forgotten. But that falls within the realm of the Almighty, blessed be He. What belongs to us, what we have to learn from this, we must learn from the past for the present and for the future. Each chapter in this book, and in the second part we plan to produce, is a bridge, a link in the chain. This is a book that cries out to be heard and taken to heart. It demands that the reader meditate on why the Almighty did these things, why He was enraged about us, what we did and what

we did not do, and what we had in our power to do. This book wants to draw a line and to improve the understanding of the readers regarding how we and all of klal Yisroel are supposed to act.

The reason for printing this book is to bring down for posterity what was wrought upon the Jewish people in recent times, as well as providing us with the opportunity for learning from the past for the future. The sins and the crimes of the nations are written in the Almighty's book in the Heavens. We do not have , today, anyone like Jeremiah, who is able to write a Book of Lamentations. The time will come when the Almighty will demand and seek justice from these genocidists for all their cruelty, all their tortures, all their murders. Not one will be left out. But the confessions and sins of klal Yisroel is something which must be written here.

"Jewish war criminals" is a phrase that was not included in the lexicon of either the "yishuv" in Eretz Yisroel or in the diaspora. It is not even found in the remotest fantasies and imaginations of anyone's mind.

On the contrary, from the hundreds of books, tens of thousands of articles and millions of words written and spoken on the Holocaust (which, itself, has been turned into a Zionist battle cry which we abhor, but have been forced to use for identification purposes), the opposite seems to be suggested - - that there were no Jewish war criminals.

For this reason, the author of this work has unfolded before everyone's eyes his uncovering of the mask worn by the Jewish collaborators, who stood at the helm of the Zionist movement and gave their hands to the Nazi beasts.

Lest you may ask, "why should we uncover this, why should we open old wounds?" this is to warn you to beware that there might be within your heart an iota of desire to serve this Zionist idol, or to get close to it and be within its realm. Know who were its leaders, even at its begininig, and develop a full comprehension of how, when Jews descend, they descend down to the abysmal depths.

CHAPTER ONE

Amongst those who sanctified the AlMighty's Name in the holocaust- - and none can reach their lofty level - - stands tall the exalted figure of the pious Rabbi Michael Dov Weissmandel, the son-in-law of the rabbi of Nitra, of blessed memory. Fortunately, he, himself, did not share the same fate as those holy martyrs, but during the five years of destruction, he stood like Aaron the High Priest - - redeemer

and savior - - between the living and the dead, trying to ward off the angel of death. All his thoughts, efforts and strength were primed for one purpose - - rescue. He, alone, remained of all his family and congregation. His injured heart absorbed the agonies of the holocaust. The war ended. Life returned to its normal course. Even the survivors began to reestablish their destroyed houses: Only he could not find solace or peace of mind. The holocaust endured inside him with all its fright. He lived it day and night, even after he arrived at the safe harbor of the United States. For many years he wrestled with doubts. Did he have the right to be silent? Or was he obligated to throw in the face of the world a full measure of the cry of Rabbi Ishmael, the High Priest, when the strippers of his skin approached the place of his tefillin?

When Rabbi Michael Dov approached the time to leave this world and return his soul to the treasury where the martyred souls of his tortured holy brethren repose, he quickly compiled the notes which were to form his book, "Min HaMaitzar" ("From the Depths"). It was published posthumously by the Nitra Yeshiva, which he had established in the United States. Bewailing the agonies of the people, as in the Book of Lamentations, as the prosecutor who has an irrevocable warrant, as an historian who writes a memorial, and as the representative of his people who confesses and atones for himself and his congregation, so arises the towering figure of Rabbi Weissmandel in his book - - this, the Lamentations of the holocaust. Above all, Rabbi Weissmandel was a Jewish leader of the same high caliber of the "parnasim" of former generations, who gave their lives for their congregations and steered their ships through tidal waves of hate with much understanding, fearless heroism and hands unsoiled with bribery. They appeared in front of the wicked of the world to rescue, protect and save those marked for death. Their work was done with quiet humility and without self-aggrandizement. "Min HaMaitzar" was not meant to memorialize the past, but was intended for more: to teach us morality, to draw conclusions from the extended front of our relationship with the world and to form the internal front of our line of demarcation with the secular Jewish establishment - - which forced itself upon the Jewish people and seized its leadership.

FIRST CONCLUSION
ETERNAL HATRED FOR THE ETERNAL NATION

From their burning desire to be free of the glorified uniqueness which the AlMighty intended for His people in the wilderness of

nations, the secular propagandists created the illusion that our relationship to the nations of the world could develop along the same lines as allies or enemies. Undoubtedly, there were a scattered few righteous individuals amongst these nations who endangered themselves to save Jews in our generation - - as some have in every generation - - and in our collective consciences, past and present, we have always remembered them with gratitude. But, as we know, the exception only proves the rule; and the majority have opposed these gracious exceptions. It was the intention of some people to present the Germans, alone, as the symbol of vice; but, in fact, many nations saw the Germans as their convenient instruments of Jew - killing. Western democracies hurried to close their gates to escaping refugees, while in Communist Russia, machine guns mercilessly cut them down and often reddened the Volga River with their blood. Tens of thousands who succeeded in escaping across the border were sent to Siberia for a slow death by starvation and hard labor - - their only crime being that they were Jewish. The Nazi labor camps had their equal in the wastes of Siberia. It seems we want to forget how those partisan groups that fought the Nazis would kill those Jewish refugees who sought their aid and even engage groups of armed Jewish partisans who were fighting the same German enemy. In occupied countries, the local populace felt strong hatred for the Nazi invaders. Nevertheless, it collaborated in exterminating Jews, either by outright murder, or by turning them over to the Nazis.

With the outbreak of World War II, Zionist leaders boastfully decreed the Jews to be a "warring nation," which had joined the Allies in their war against Germany. But the Allies never accepted the outstretched hand of this uninvited friend. Churchill's Britain offered, to butchered Jewry an impressive ceremony of standing in silence in Parliament. At the same time, it willfully issued only a restricted amount of entry visas and allowed thousands to perish. Similarly, Roosevelt's America refused to loosen its immigration laws. At first, the German occupation forces refused to activate the racist laws against Jewish citizens of other countries for fear of reprisals against German nationals abroad. They quickly discovered no grounds for their concern, however, as the Western democracies issued no complaints in the face of the murder of their Jewish citizens. Thousands of bombers were flown nightly by the United States and Britain to destroy German cities, but in the death houses of Auschwitz, Maidanek, and Treblinka, the inmates searched the skies in vain for a single bomb to prevent one furnace from burning 13,000 Jews per

day. In his many letters, Rabbi Weissmandel implored the Allies to bomb the extermination camps and especially the railroad tracks that led to them. For this purpose, he drew up exact plans of the camps and precisely mapped out their railroad systems. One of the letters fell into the hands of Germans, who mocked its message by saying: From now on, whenever Germans want to secure their trains from enemy bombs, all they have to do is write in large bold letters on the roof of the trains that they are transporting Jews for extermination. There was much truth in this mockery. There existed an unwritten understanding between the two fighting blocs; the Germans would exterminate Jews and the Allies wouldn't stop them, but would only offer words of protest and consolation. The Jews in Poland had an expression: if a Pole meets me on the wayside and doesn't kill me, it is only from laziness.

In the days of the holocaust, the Gentile world was split in half: Half the planet turned into an ax and their inhabitants into executioners, while the other half became an impregnable, closed fortress with its inhabitants standing by with indifference or with gloating. The historical axiom of eternal hatred to the eternal nation is not broken by the exceptional phenomena in Scandinavian countries, because this same axiom has a qualifier which states: the strength of anti - Semitism exists in proportion to the percentage of Jews in the Gentile population, and to the importance of their contribution to culture, econmics and politics. The Scandinavian concern for the Nazi victims derives from the infinitesimal percentage of Jews in these countries...

SECOND CONCLUSION:
THE CATHOLIC CHURCH - - THE CRUEL ENEMY

From the day we were exiled from the Holy Land, the Catholic Church was worse to us than all the kings of the earth. All its steps on the stage of history were tracked with Jewish blood. One of its unwritten laws is that the Jews deserve the worst punishment for rejecting their "savior" with two hands.

Rabbi Weissmandel writes, in "Min HaMaitzar": "In Nitra, there was an 82-year-old archbishop named Komenatka. When the deportations from Slovakia began in the year 1941, Rabbi Samuel David Ungar, the rabbi of Nitra, was entreated to go plead before the archbishop to halt the deplortations. The wicked old man said to the rabbi of Nitra: 'This is not just deportations. There you won't die from hunger and disease. There you will be slaughtered: from the elderly

to the infants, children and women - - all in one day. And this is the punishment you deserve for the death of our savior. You've only one alternative - - to convert. Then I will try to cancel the decrees'."

Terrible years passed and in the year 1944, the ax fell on the last of Slovakian Jewry. Rabbi Weissmandel endangered his life by appearing in front of the Papal Nuncio and describing to him the terrors of Auschwitz. He pleaded against the deportation of more than 20,000 Jews. The Papal Nuncio threatened Rabbi Weissmandel with an immediate Gestapo arrest and added: "There is not a Jewish child in the world without blood - guilt. All Jews are liable in this matter and deserve to die - - and this is the punishment awaiting them for that crime." This representative of the Church demanded that the prime minister of Hungary mercilesslly murder Hungarian Jews, as was done in neighboring Slovakia.

It is not a coincidence at all that there are some reports that the Vatican helped Eichmann in his flight, and equipped him with a bogus passport. The same demon (Eichmann) drew upon the Catholic Church for his inspiration for the final solution to the Jewish problem. The yellow badge and the ghetto were the Satanic inventions of the Catholic Church, and were employed for hundreds of years. The passionate commitment of Eichmann to root out every last hiding Jew and to exterminate him has precedents in the Church's Inquisition, which zealously tracked down the remainders of the forced converts. Eichmann proclaimed during the Israeli investigation that he deplored mass murder by shooting, since it develops sadistic tendencies in the executioners. He therefore preferred murder by poison gas. Even here is heard the echo of hypocritical Catholic piety which, because Christian love forbids bloodshed, recommended for its victims death by conflagration (auto de fe). The Inquisition, which burned at the stake tens of thousands of Marranos, developed systems of torture and perfected special mechanisms for such situations. The Popes have graced this epoch with the title, "The Holy Inquisition." We can only suppose that if the Church's hand was as strong as it was in medieval days, it would confer upon Eichmann, too, the title of "holy", and would set aside a day for honoring "Saint Adolf" on its calendar. When the former Pope, Pius XII, died, the heads of the World Jewish Congress and representatives of the State of "Israel" hurried to sing the praises of this sly enemy of the Jewish people, while Reform and Conservative "rabbis" competed in their displays of mourning and portrayed him as a savior of Jews during the holocaust.

What is the historical truth? The Pope did take a few steps to prevent the expulsion of Italian Jews, and so continued the pious Vatican tradition. But as the Popes of the past, who were the architects of persecution and slaughter of Jews in Catholic Europe throughout the Middle Ages, supposedly defended the lives of the Jews of Rome and other Italian cities - - thus demonstrating, by public actions, Catholic "piety" - - it was not until the year 1945, i.e., until the fall of Germany, that the Pope published his annual pastoral letter, which would have discredited anti-Semitism and supported the saving of Jews from slaughter. Specifically, the Catholic population in all the German occupied countries slaughtered Jews without pity, encouraged by their priests. The Poles, Lithuanians, Austrians, Croations, Slovaks and Hungarians were all fanatical Catholics, and all had unsatiable appetites for Jewish blood. Those cruel pythons, the Polish clergy, instigated - - **after** the fall of the Nazis - - pogroms of those Jews who had miraculously survived. It was no accident that the Nazis chose Slovakia as the first country to send her Jews to extermination in Poland, agreeing to pay more than 500 German marks for each expatriated Jew. Slovakia was the only state at whose head stood a Catholic priest: Tisa. By doing this, the Nazis wanted to demonstrate to all the European nations that there was no place for pity or for conscience. They pointed out that an independent Catholic nation whose president is a priest was leading the way in extermination of its Jews.

Rabbi Weissmandel presents a shocking document of the serpentine slyness of he who occupied the Papal chair. When all the rabbis of Slovakia sent the Pope a petition to halt the deportation of Jews to Auschwitz, there came from the Pope a reply looking like sympathy on the outside, but tasting of poison on the inside. His reply, which sealed the fate of Slovakian Jewry, expressed his wonder that "a state that recognizes itself as a Catholic government should take on itself to expel 135,000 Jews to Poland, **separating men, women and children,** and causing much pain to so many families. The pain increases when the Slovakian government decides to expel all the Jews without exception, even those who had converted to Catholicism. The Holy See would not fulfill its Divine purpose if it would not express its sorrow at these decrees, which hurt its faithful sons, as exile will drive them from their new-found faith." The Slovakian government picked up the intimations of the Pope's letter and subsequently reached two decisions which were communicated to the Pope: From then on, Jewish families would be **expelled together, not separately;** and the decrees of exile

would not affect those who renounced Judaism. The Pope' mind was eased, and when the Slovakian head of state, the priest and murderer, Tisa, was sentenced to death after the war, the "merciful father" of the vatican shed a silent tear over him.

"Know the enemy" is the first rule of self-defense. As long as Jews were healthy in their historical sense, their nausea for the Church was rooted in their nature. In our generation, the disruption of Judaism has caused a loss of perception. The government of the "State of Israel" displays deference towards the Church, and some distinguished Israelis - - not only a few poor people - - educate their sons in missionary schools. Many youths flock to church to experience Christian holidays, and there is a tolerant attitude towards Jewish converts to Christianity and towards mixed marriages.

The active advocate of apostasy, Sholom Ashe, who had been alienated from his brothers in the United States, was received in Israel with admiration and honor. Al l these indications foreshadow severe decline. The secular nationality whach rejects Judaism, blurs the separation between Jews and Christians, and seeks a neutral stance. Religious and cultural obliteration looms ominously in the vacuum.

CHAPTER TWO

The following quote is recorded in the documentary files of the Jewish Agency for the era of the holocaust:

> We have been informed that in a certain community in Poland, all the Jews of the congregation were assembled together in the shule. The Holy Ark was opened and the Jewish world leadership was cursed.

Was this perhaps an outburst of demented people doomed to die? Not at all. Even though these unfortunate Jews did not predict the imminent tragedy, their intuition foresaw more than what they consciously knew. Hitler had two diabolical collaborators without whose help he would not have been able to complete his work: the active and passive assistance of the Christian nations (including both those whom he conquered and those who were his allies) and the Jewish leaders of the conquered and free nations, alike, who violated their trust and stood by while innocent blood was shed.

At the time that Rabbi Michael Dov Weissmandel published his "Min HaMaitzar" ("From the Depths"), I wrote a review in "Digleinu", in which I intended to summarize three general conclusions from that book:

1. eternal hatred to the eternal nation
2. Amalek in the guise of the Catholic Church
3. the Jewish criminals of the holocaust.

The Eichmann trial was then in progress, and my pen hesitated at that time to make the indictment against the criminal descendants of Abraham. Therefor, when my pen came to point three, it desisted. Much water has since flowed into the seas upon which Eichmann's ashes were scattered, and we are no longer permitted to ignore Rabbi Weissmandel's last testament, which was written in blood. We cannot allow forgetfulness to set in for the sake of convenience.

WOLVES IN SHEPHERDS' CLOTHING

In his speech at the Eichmann trial, the prosecutor stated that it was not the occasion to inculpate the Jews who collaborated with the Nazis, which is a chapter unto itself. And indeed, though the trial of the holocaust's Jewish culprits did not take place in the Beit Ha'am Auditorium in Jerusalem, it would be no less horrifying and unnerving - - and possibly a lot more - - than Eichmann's trial. Nor are we free from staging it in our hearts or evading it altogether.

The Eichmann trial had a double purpose: that of seeking justice against the beastly instincts in man and that of educating us to the nature of the wickedness of nations. As for the shadow trial which must be held against our own brethren, its sole purpose is educational. Secularism must be placed upon the prosecutor's bench of the guilty and exposed as the mortal enemy of our people.

There were Jews who could not resist the test of boot and whip-lash and, by turning informer upon their brethren, by rendering them unto the hangman or making them scapegoats of the kapos and the Jewish councils, gained their own freedom. Since we were not subjected to their trials, it is questionable if we can judge them in the full severity of the law. Not every generation merits foremen who are willing to sacrifice themselves as did the Jewish foremen in ancient Egypt.

But here lies the paradox: the state which designates itself as "Israel" has on its books a law demanding justice to be meted out to Nazis and their collaborators, but for those laden with guilt who stood at the helm of Jewry during the holocaust, there is no law to call them to account. Not only that, but those who have died in the interval are lauded and revered, and those who are yet alive maintain their respected positions, as they continue to prop themselves up as representatives of the Jewish people. While we angrily demand that the

Bonn government remove Nazi Hans Gloebke and his cohorts, let us condemn ourselves for not removing parallel figures from our own public stage. While the Bonn government has not dared send Gloebke to address a memorial ceremony for Bergen Belsen, several days ago, on Holocaust Day (1961), Yitzchak Greenbaum spoke in the Chamber of the Holocaust on Mount Zion without any protestors in evidence.

Dr. Nachum Goldmann, president of Zionist organizations and president of the World Jewish Congress, admitted this year in a public forum commemorating the Warsaw ghetto uprising: "We all are blameworthy, not only in the causative objective factors, but also in the absence of that fervent will and unbridled readiness to adopt any and all necessary measures possible in that period."

We shall return to Dr. Goldmann's speech, but let us first present two questions: 1) Why did he wait with this confession for 20 years and 2) Why does he not reach personal conclusions towards the blame which he admitted? Why is he satisfied with a general verbose confession, which he thinks suffices to atone for the past, while enabling him to continue in the future to hold his powerful positions?

Who bore us these Jewish holocaust criminals? What earth nurtured these thorns and thistles in the Jewish vineyard? What befouled and poisoned spring watered such moral depravity and brotherly hatred towards unfortunates, evident in the extent of their willing and diligent service as beasts of prey in the destruction? Let us hear an account from the famous writer and critic, Y. Efroiken, a standard bearer of secularism whom the holocaust brought to the gates of repentance. In his book, "Sanctity and Valor of the Jews", he writes:

From where did the thousands of Jewish police (kapos), who served the Germans in the concentration camps and the ghettoes, come? From which circles was this infamous army recruited? The survivors of the holocaust all concur that they originated from the underworld and from the 'maskilim' - - the very people who denounced their 'unenlightened' brethren for their traditional garb. Did not these maskilim harbor the identical feelings of scorn and even hatred of their masters and officers, the Nazis?

"Question survivors of the ghettoes and camps. They will certify that the beatings they received at the hands of the Jewish 'golden youth' were filled with scorn. They fulfilled their tasks with a zeal and a cruelty to a greater extent than that required by the German commanders. One is at a loss to understand why the renunciation of Judaism goes hand in hand with renouncing humaneness, why shruggling off the inner G-dly Jewish form

automatically denudes one of human form and human values. Here one must record the blatant fact, verified by witnesses (including Communists, bundists and Zionists), that Torah - true Jewry - - Jews wearing traditional rabbinical or chassidic garb - - never held positions in the Jewish police force, which administered ghetto Jewry, and never served as kapos or officers. Even Gentiles sympathetic to our people, who sought to describe outstanding personalities or singular heroism in the camps, could only find such examples from amongst Torah observant Jews, who never meted out beatings, who starved rather than defile themselves with 'trefos', who shared their last crust with the weak and the sick.

K. Tzetnik, famous chronicler of tales of the holocaust, who fainted and became critically ill after he began testifying at the Eichmann trial, offers corroborating evidence in his book about Auschwitz, "Call Him Feifel". There he depicts the figure of Eliezer Greenbaum, son of Yitzchak Greenbaum, who thanks to his tactics of acting as informant and displaying cruelty - - to an extent which amazed even the Germans - - was elevated to the rank of the bloc commander.

In K. Tzetnik's words, "he hated religious Jews with an abysmal loathing. His eyes would shoot flaming sparks whenever a religious Jew, and even moreso a rabbi, fell into his clutches. And so, when he murdered a Jew named Heller, he summoned two other Jews from the barracks. 'Who is the rav?' he asked. The one who was a rabbi had his bearded face covered with a rag, which had once been part of a coat sleeve. Fruchtenbaum (Greenbaulm) measured the two men with a scornful glare, his features clearly showing how it irked hm that such Jews still existed. He turned to the Shilover Rebbe and, in an anti-Semitic tone, rolled out a threatening 'rebbetzin' from between clenched teeth, while his brain toiled to devise a method of death for the pair."

K. Tzetnik reveals the inner fantasies of an Auschwitz inmate:

His father, the Zionist leader, will surely be the first to arrive in Auschwitz in order to roll in its dust and to throw the first stone at the corpse of his hanged son. The unfortunate Fruchtenbaum (Greenbaum) will blame himself as if his own hands wielded the club his son used. He will not know how to lament and to mourn. Undoubtedly, to the end of his days, he will dress in sackcloth with ashes on his head, culled from those cremated Jews whom his son murdered. Is not the son a limb of his father as the fruit is an extension of the tree? A percentage of Jewry would still be alive had the father of

the Nazi lackey been a small merchant, a shoemaker or a shammos in a shule. Who knows how many Jews would have been alive today had the Zionist leader Fruchtenbaum been childless?

What actually happened is well known: Yitzchak Greenbaum strides amongst us, his bearing erect, surrounded with the glory and honor of a celebrated Zionist leader. His son, the murderer, escaped to Eretz Yisroel, where his life was finally terminated, not by an Arab bullet, but by a Jewish avenger. And despite this, his name is memorialized in the "G'veelay Aish" ("Parchment of Fire") book that commemorates the fallen of the Zionist War of 1948.

The father knew that it was from him that his son inherited his virulent hatred for Torah - observing Jews, for in his own home and from his own mouth he had heard the motto, "death to Orthodoxy." He executed his father's wicked thoghts.

The Yevseks (Jewish Communists) in Russia and the kapos in the ghettos and the camps all were nurtured from the same maniacal hatred towards Jewish tradition and its upholders. It is possible that they subconsciously blamed Orthodox Jewry for resisting and deterring complete assimilation of Jewry and thereby perpetuating the Jewish problem, while causing international discontent. Placing the blame upon traditional Jewry appeared to them the only logical explanation for the evil that befell them. Since they did not believe in the basic tenets of reward for mitzvos, punishment for sins, and the ultimate obligation of accounting for oneself before the AlMighty, they could give their darkened minds free reign.

Romkowsky, serving for decades as the chairman of the Zionists in Lodz, had himself crowned, under Nazi slonsorship, "king of the ghetto." He treated his "constituents" with the ruthlessness of a maniacal tyrant, augmenting Nazi decrees with his own, organizing with methodical precision and without pity all death transports, appointing himself as the sole marriage performer for young couples. Alfred Nussing, the elderly Zionist leader and personal friend of Herzl, blemished his old age by informing and spying in the Warsaw ghetto, for which he was judged and sentenced to death by the underground.

These names are mentioned as blatant examples, but the infamous list itself is long and spans many cities and villages throughout Poland, Lithuania, Hungary and Romania.

The AlMighty created these to offset those. And to counter the individual secularists - - those who perpetrated the wickedness - - on the one hand, we have a multitude of tens of thousands of believers,

mostly nameless heroes, whose deeds shine brilliantly with their love for G - d and His people in a display of the three Jewish traits of mercy, humility and lovingkindness, which all the horrors of the holocaust could not extinguish. Their praises have yet to be sung, for only in the Book of the Omniscient One are these righteous and humble people chronicled for what they did.

Only one remnant survived, like a log extracted from the fire - - Rabbi Michael Ber Weissmandel, may this holy saint's memory be blessed - - to demand justice. So long as there remained one last hope, he would not remain silent. And even after it was too late, he refused to resign himself and forget the Jewry that had been annihilated. He was the great prosecutor in the shadow trial, which he conducted against secular world Jewish leadership. His indictment of incrimination is emblazoned in fiery letters in this work, "From the Depths" ("Min Hamaitzar")

This book, however, only tells part of the story; it only included the details known to him and at his fingertips. In his situation, Rabbi Weissmandel was unable to delve into and investigate the facts that were revealed to him only after he escaped danger. His heart was unable to contain more and burst within him. He fell victim to the massive burden of crimes of those collaborators who stood by calmly while Jews met their untimely, cruel deaths. These traitors resembled fish ensnared in net, endeavoring to escape by fair means or foul, while the whales, the secular leaders, were in secure places and continued ploying a diplomacy in which millions of imprisoned Jews were exploited like pawns on a chessboard.

BLOOD IN EXCHANGE FOR A STATE

Zionist, leaders during the holocaust did not stop at manipulating lives. They also controlled the sources of finance and communications, representing themselves before the world as the spokesmen of the Jewish nation. They, alone, are responsible for the unfulfilled potential in rescuing the Jewish people. In three vital areas they failed and impeded other efforts: 1) in communications, 2) in material aid and 3) in preventing annihilation. Had these failures stemmed from ignorance or mistakes, one might excuse their lack of ability, but the bitter truth is that their actions were determined by explicit policy and a fundamental principle. The first and foremost aim was to establish the "state" - - the masses of Jews merely served as convenient means. And wherever there existed a contradiction between the two, the needs of the masses, and even their salvation, were subordinated to the needs of the state-in-formation. In the year

1905, the riots and pogroms that broke out in Russia were welcomed with blessings by the Jewish socialists who, together with their Russian counterparts, consoled themselves that Jewish blood was good grease for the wheels of the revolution. The Zionist leaders saw the spilt Jewish blood of the holocaust as grease for the wheels of the Jewish national state. And as a general sacrifices thousands of soldiers for the sake of capturing one fortress, so did the Zionist leaders bloody their hands in building the state of "Israel" and sacrifice Jewish children of the diaspora in the fortification of its walls.

Eliezer Liveneh is worthy of praise for his courage in at least admitting this in his column, "Thoughts on the Holocaust" (Yediot Achronot, 25 Nisan). He writes: "Our Zionist orientation educated us to see the growing land of Israel as the prime goal and the Jewish nation only in relation to its building the land. With each tragedy befalling the Jews in the diaspora, we saw the state as the evident solution. We continued employing this principle even during the holocaust, saving only those who could be brought to Israel. The mandate's limitation on immigration served as a political factor in our battle to open the doors to aliya and to establishing the state. Our programs were geared to this aim and for this we were prepared to sacrifice or endanger lives. Everything outside of this goal, including the rescue of European Jewry for its own sake, was a secondary goal. If there can be no people without a country,' Rabbi Weissmandel exclaimed, 'then surely there can be no country without a people. And where are the living Jewish people, if not in Europe'?"

Let us bring historical evidence to support the above.

In the Zionist Congress which took place in London in 1937, Dr. Weizmann established the line of policy with his words:

The hopes of Europe's six million Jews are centered on emigration. I was asked, 'Can you bring six million Jews to Palestine?' I replied, 'No'.....From the depths of the tragedy I want to save two million young people... The old ones will pass. They will bear their fate or they will not. They were dust, economic and moral dust in a cruel world... Only the branch of the young shall survive... They have to accept it.

Many of the passengers are old people and women...unable to endure the harsh conditions on this type of trip...to come to Palestine are needed young men and women who understand the obligations of a Jewish national home... there could be no more deadly ammunition...than if Palestine were to be flooded with very old people or with undesirables...

In his book, "In Days of Holocaust and Destruction," Yitzchak Greenbaum writes, "when they asked me, couldn't you give money

out of the United Jewish Appeal funds for the rescue of Jews in Europe, I said 'NO!' and I say again, 'NO!' one should resist this wave which pushes the Zionist activities to secondary implortance."

In January, 1943, the leadership of the absorption and enlisting fund decided to bar all appeals on behalf of rescuing Jews. It is explicitly stated in the "Sefer Hamagbis" (Book of Appeals) that the reasons for this prohibition were because of other obligations in Eretz Yisroel.

In the beginning of February, 1943, Yitzchak Greenbaum addressed a meeting in Tel Aviv on the subject, "The Diaspora and the Redemption," in which he stated:

For the rescue of the Jews in the Diaspora, we would consolidate our excess strength and the surplus of powers that we have. When they come to us with two plans - - the rescue of the masses of Jews in Europe or the redemption of the land - - I vote, without a second thought, for the redemption of the land. The more said about the slaughter of our people, the greater the minimization of our efforts to strengthen and promote the Hebraization of the land. If there would be a possibility today of buying packages of food with the money of the "Keren Hayesod" (United Jewish Appeal) to send it through Lisbon, would we do such a thing? No! and once again No!

The following is addressed to my acquaintances: When Greenbaum expressed these shameful views, he served as chairman of the acting committee for the rescue of European Jewry. The wolf was appointed by beasts of prey to serve as shepherd for a flock of sheep. But he was not the only wolf to masquerade as a shepherd.

Mr. Nathan Schwalb sat in Switzerland and served as the representative of the Jewish Agency, exercising authority upon matters of rescue. When he was approached by the rescue committee of Czech Jewry for a sum of money to halt the transports to Auschwitz, he answered in a letter that serves as a historical document we would do well to repeat:

Since we have the opportunity of this courier, we are writing to the group that they must always remember that matter which is the most important, which is the main issue that must always be before our eyes. After all, the Allies will be victorious. After the victory, they will once again divide up the world between the nations as they did at the end of the first war. Then they opened the way for us for the first step and now, as the war ends, we must do everything so that Eretz Yisroel should become a Jewish state. Important steps have already been taken in this matter. As to the cry that comes from your country, we must be aware that all the nations of the Allies are spilling much blood and if we do not bring sacrifices, with what will we

achieve the right to sit at the table when they make the distribution of nations and territories after the war? And so it would be foolish and impertinent on our side to ask the nations whose blood is being spilled for permission to send money into the land of their enemies in order to protect our own blood. Because "rak b'dam tihyu lanu haaretz" (only through blood will the land be ours). As to yourselves - - members of the group - - "atem taylu" ("you will get out"), and for this purpose we are providing you with funds by this courier.

Here Mr. Schwalb expressed the complete Zionist ideology and stated clearly and openly the politics of the Zionist leaders in the area of rescue: the shedding of Jewish blood in the Diaspora is necessary in order for us to demand the establishment of a "Jewish" state before a peace commission. Money will be sent to save a group of "chalutzim" (pioneers), while the remainder of Czech Jewry must resign itself to annihilation in the Auschwitz crematoria.

When Rabbi Weissmandel received Schwalb's answer, he was reminded of the two warnings he had received from his father- in - law, the holy rabbi of Nitra, that in rescue work he shouldn't pin any hopes whatsoever upon either the Catholic Church or the World Zionist movement. He blamed himself for wasting his time by not heeding this warning and subsequently vainly expending mighty efforts which he could have directed to more beneficial area.

It is common knowledge that Eichman proposed to Dr. Kastner's committee that Jewish lives be exchanged for merchandise, a proposal which he termed, "Merchandise in exchange for Blood." Zionist leaders read this bid differently: "Blood in Exchange for the State."

We have discussed at length and have not touched upon more than a beginning. There is not enough paper to list all these tragedies, and the soul of both the readers and writer cannot digest all this material at one time. The portion of misery and lain overflows its bounds and one must have a breather in order to comprehend these chapters and to let them be engraved deeply in our hearts. One must not let the frightful crying and sighing of the saint of the holocaust - - Rabbi Michael Dov Weissmandel - - be smothered between the pages of his book. Rather, we must let his weeping enrage and enervate us in measure with his last plead - - not to forget or let be forgotten the blame of the secular leaders for the blood of their brethren doomed to death in the crematoria.

YOURI ANDREEV
from *Zionism: Propaganda and Reality*

{Here we are presented with the official Stalinist interpretation of nationalism as it follows from the point-criteria definition of a nation provided by Stalin, in particular as it pertains to the definition of the Jewish people. In spite of the recognition granted the Jewish people by V.I. Lenin ("the most oppressed and persecuted nation -- the Jews")[1], the Communist Party and its affiliates have come to disregard the existence of the Jewish People.

Accordingly this perspective has discovered the existence of the Palestinian nationality and at the same time undiscovered the Jewish nation, which it treats as being identical to the State of Israel. Undoubtedly this approach will seem similar to the general attitude of the "Left" common to North America, and such a similarity is no doubt as true as the similarities between Stalinism and liberalism. The Marxist-Stalinist vision of social reality has followed a most tortuous course beginning with its racialist origins in Marx's polarized world view of an Occidental versus Oriental hierarchy, so unlike the yin-yang duality originating with the Oriental Bach Viet society.

Many will nonetheless find this reading to be appealing because of its apparent simplicity in counterposing one people's nationalist aspirations against another's. In methodological terms, this would be equivalent to the Zionist practice of holding one people above the other in priority. Precisely the same position was the official line in 1948 when the Stalinist leadership chose to support the establishment of the State of Israel even after it had occupied territories beyond the Partition Plan resolution of the United Nations General Assembly. Such is the path of opportunism.

This analysis, while referring to the Jewish people in our entirety, identifies us with the Israeli State alone, excluding the non-Israeli Jews. This is of course an analysis of the Palestinian revolution and this is what most non-Jews expect. What is not considered is that any analysis of the Palestinian struggle is incomplete without an analysis of the Jewish nationalist movement, in both its bourgeois-occidentalist Zionist aspects and in its revolutionary socialist organizations. The motivation for an integrated internationalist analysis rests upon the need for a solution to a war that has defied resolution for some forty years or more.

If peace is to be considered the proof of an analytical resolution then the proposed framework must be internationalist in scope. It would seem that any other approach becomes reduced to a dichotomy of evil versus holiness, pitting one people against another without seeking the liberation which each truly seek in their own eternal desires. This must necessarily mean liberation from that which oppresses, and the utmost in repression is war. Without an alternative to Zionism, the Jewish public will perforce continue to wage war until their defeat, which perhaps includes the use of nuclear bombs and, or chemical weapons. -e.W.}

PREFACE (translated from French)

> Zionism is a phenomenon unique of its kind in the history of
> contemporary nationalism.
> Arthur Hertzberg 2
> Now, if you listen to my voice, and if you keep my covenant, you will
> belong to amongst all the people.
> You will be for me a kingdom of priests and a sacred nation.
> Exodus XIX (5,6)

Zionism... it is difficult to find another notion in contemporary political life arousing so many diverse and contradictory ideas at the same time. According to certain followers of this theory, Zionism is the culminating point of Jewish nationalist aspirations. The movement of Jewish national liberation[3] is placed in the same rank as the movements affirming the victory of the sovereign life and independence of nations. But if one refers to the tragic experience of those who are subservient to the politics of Zionists on the Arab lands occupied by Israel or the discriminatory regime of relations between the countries prescribed by Zionist doctrine, then Zionism is neither more nor less than an ideology of racism, of racial discrimination and intolerance, a manifestation of political immorality, of adventurism, the personification of a cult of all-permissiveness, the practice of a cruel violence.

Zionism is far from being understood in the same one-to-one manner by those who praise its merits. For the leaders of Israel, for example, who aspire to the role of "high priests" of Zionist ideology, Zionism is above all "the reunification of the Jews of the entire world on the promised land." The most diverse representatives of bourgeois nationalist currents in that which is called the diaspora[4] often

refute, for diverse reasons, the "Israelocentrist" model of Zionism and put into doubt the "need" of the Jews aspiring to be installed in the "new Zion."

Other champion zealots of Zionism in the diaspora discover, upon arriving in Israel, that the traditions and norms of the Israelis are incomprehensible and foreign to the Jews of America, France and Great Britain. After all, today, more than 60% of the Jewish population of Israel is composed of those originating in African countries of the north and of the Near-East. The "oriental" Jews, as much by their appearance as their mode of living, their mores or habits, are different from the Ashkenazie "white" Jews, immigrants of Europe and America...

There exists however a common thesis for all the theoretical varieties of Zionism concerning the existence of a "world Jewish people" all of whom the Zionists have arbitrarily made citizens of the Jewish nationality, no matter where they live or whatever may be their political or ideological opinion, their social situation, their attitude towards bourgeois Jewish nationalism, Zionism, or the politics of the Israeli authorities. In the conception of a "world Jewish people" borrowed from the Judaic theology, the Zionists lifted not only the idea of the sacredness of Jews and of their nature as God's elect, but also the immanent aspiration appropriate for Jews of a supranational unity supposedly experienced at all times, knowingly or not, by all the members of the "chosen people."

From the religious-mystical idea of a "world Jewish people," the Zionists throw a bridge towards the already concrete political idea of the "State of Jews of the entire world." The creation and guarantee of the existence of this State rested and still rests at the center of the Zionist theoretical premises and practical efforts.

At the moment when Zionist theory acquired its dogmatic form, in the works of the Viennese journalist Theodor Herzl (1860-1904), the conditions of life of Jews in various countries did not have anything whatsoever in common, obviously, with "biblical" conditions. During the impetuous development of capitalism, the Jews had participated, in the same manner as the inhabitants of other nationalities, in grandiose social transformations. Nationalism, chauvinism, the propaganda of the "particularism" of certain peoples and the "inferiority" of others has been largely put to profit by the bourgeoisie in order to direct the behavior of the masses.

Thus, the bourgeois Jews had the same task to accomplish: to use their influence over the masses of the Jewish population to rein-

force their positions in the grim competition against the capitalists of other nationalities. The means employed to attain these objectives are the same: nationalism, propaganda of the superiority of "their" nation. However, the situation is complicated by the fact that it isn't easy to identify "their" nation, because the Jews are living in the most diverse countries of the world, and have for a long time made their own the languages, traditions and culture of the peoples among whom they were living. The sole argument which they can hang on to in order to prove the "community" of all the dispersed groups of the Jewish population is the so-called unique religion, Judaism.

The Israeli author Akiva Orr presents us with a typical example of "the function of Judaism as a means to constitute a people": "For two thousand years, the Jews have lived in essence as a minority community, dispersed throughout the whole world. During this lengthy period, they have assimilated numerous traits of the local societies. At length, the various Jewish communities began to become distinguishable from each other by language, clothes, food, traditions and even physical traits, and that so markedly that any observed who is not the same could doubt that they would be closely associated...The line which connects diverse Jewish communities -- and which separates them from societies where they evolve -- rests in the Jewish religion."[5]

However, from the century of Enlightenment onward,[6] the level of devotion amongst the Jews from most countries began to diminish considerably, which hasn't, besides, been without torment to the clerical Jews, the rabbis, who are seeing in the erosion of Jewish religious consciousness a threat to their positions in the Jewish community.

Zionism has been the response of the will of the Jewish bourgeois oligarchy -- as much secular as clerical -- to stop the disintegration of the communities through re-affirmation of the idea of Jewish isolation. Additionally, this supranational theory is meant to discourage the growth of class-consciousness among working-class Jews, turning them away from the international proletarian struggle. It isn't accidental that the development of Zionist theory and practice has borrowed from several directions from the start. Like "religious" Zionism, the "workers'" Zionism, and "general" Zionism, as well as a whole series of varieties of Zionism, appeared nearly simultaneously. All are meant to indoctrinate certain layers of the Jewish community -- from the determined followers of Judaism to the Jewish proletarians who have ceased to expect the grace of the God Yahweh, who have

supported the heavy burden of economic, social and national inequality.

The political program of the Zionists, published at the first congress of the World Zionist Organization in 1897 in Basel, presents for an objective "the creation, for the Jewish people, of a home (refuge, house)7 in Palestine." This being given, the correlative methods and means to be applied in order to attain that end were defined: 1. development of Jewish agricultural, artisan and industrial communities in Palestine; 2. organization and union of "all the Jews" by means of appropriate local and international institutions; 3. reinforcement of national Jewish consciousness; 4. agreement from governments in order to attain the objectives of Zionism.

One may note that from the very first, it was placed in the Zionist platform, as essential, the relative tasks which were seen as suitable to the diverse "parties of the Jewish people", as well as the propaganda of universal Zionist ideas. In fact, the Zionists' objective is to create a "Jewish people" or at least the appearance that such a people not only exists but also possesses a certain "common will" of which these same Zionists wished to be the interpreters.

The two following facts show that it was mystification, or more precisely, a usurpation of the positions and opinions of people who knew nothing of Zionism. Right after the World Zionist Organization's Congress of Basel, Theodor Herzl wrote in his personal journal: "I am occupied with Jewish affairs, without having the slightest mandate for it." 8 This, despite the fact that since 1903, at the VIth Congress of the WZO, Max Nordeau, one of those close to Herzl, declared: "...this congress is the legal and accredited representative of the Jewish people. Its duty is to apply the Jewish national politic."9

The leaders of the Jewish communities in the principal capitalist countries have rapidly understood the value of having a program for themselves of a "territorial solution for the Jewish question," as well as the methods of its realization tied above all to the unlimited propaganda of nationalism and chauvinism. From the beginning of the '40's, Zionism became the dominant current of Jewish bourgeois nationalism.

Correspondingly, the Zionists have worked relentlessly to win the leading elements of the most powerful imperialists and, at each step of their activity between the two world wars, they have always banked on the strongest of these powers. In the 40's of the 20th century, the alliance of Zionism with American imperialism took shape, which then became transformed into the "special" American-Israeli relations.

When, in 1948, the Zionists torpedoed the United Nations resolution on the partition of the former territory of Palestine then under British mandate into two states -- Jewish and Arab -- the State of Israel, in which they seized power, appeared. This marked the beginning of the upheavals, conflicts, wars and human suffering in the Near-East which endure until this day.

Israel became 40 years old in 1988. Today, the Zionists work hard to prove that these four decades have been the most outstanding in the history of the Jewish people over the course of the last two thousand years. What metaphors have not been invented for Israel: "the realization of the secular dream," "personification of their messianic vocation," "expression of the will of God," etc.. There is even a conception of Israel as that "new symbol of faith" in Judaism, Zionism itself even being proclaimed the "new (secular) religion" of the Jews. The exaltation of the champions of Israel knows no bounds. We are, however, far from a lucid analysis of the facts: it is easier and more habitual to take these desires for reality, to manipulate again and always the myth of a "single world Jewish people", completing the latter with eulogies on the "single Jewish state."

"*The Jewish people* (as defined by the American dictionary), *dos yiddishe folk* (as named by those who speak yiddish), and *am yisrael* or *ha'am ha'gehudi* (as this notion is rendered in Hebrew), writes author Edward Glick in the spirit of Zionist rationalizations on the theme, signifies a transnational, multilingual, historic and religious group, affirming its unity, its community, its integrity, its solidarity and its partnership, put forward over several thousand years.[10] In a breath, without ceding to Herzl or Nordeau, Glick affirms straight out that all that he has said on the subject of the "Jewish people" concerns all the Jews of the world, *whether they understand it or not, whether they want it or not* {italics added by the author}.

Such are the Zionist illusions. But the point is that there are also 40 years of reality and, above all, real human tragedies which are closely tied to Zionism and to Israel. There is the Israeli society which, even without a particularly detailed study, offers a picture of revolting problems, of contradictions, of human suffering and ills.

"The reality of the Jewish past and present has been so altered by myths and legends, and in addition, the rabbis and other heads of the Jewish community keep such a silence in the face of evil, that only an historic, moral and political analysis of the life of the Jewish people will permit them to understand that they venerate a false god,"[11] writes the American, Roberta Feuerlicht, who endeavors to

unmask, starting from a bourgeois-liberal position, the evil perpetuated by the Zionists, the evil which they still perpetuate against the people, including even the Jews living in the diaspora as well as the Jews in Israel.

In these most diverse manifestations, these political alterations -- carried on openly as pogroms and terrorism or on the other hand under a liberal or pacifist mask -- Zionism must be denounced. This responds to the vital interests not only of the direct victims of the Zionist violence: Palestinians, Arabs, Lebanese, other inhabitants of the Near-East and the adjoining regions, but also in the interests of the Jewish population of Israel and the communities of the diaspora.

1 V.I. Lenin, *Critical Remarks on the National Question & The Right of Nations to Self-Determination*, Scientific Socialism Series, Progress Publishers, Moscow, 1971, P. 13 para. 5

2 Arthur Hertzberg, *The Zionist Idea*, Greenwood Press Publishers, 1970, p. 15.

3 Dan V. Segre, *A Crisis of Identity: Israel and Zionism*, Oxford University Press, Oxford, 1980, p. 7.

4 Diaspora (literally "dispersion") signifies the existence of certain groups of Jewish population in various countries of the world outside of Israel. Here, this term signifies the collection of Jewish communities in the capitalist world.

5 Akiva Orr, *The Un-Jewish State: The Politics of Jewish Identity in Israel*, Ithaca Press, London, 1983, p. 1.

6 Ideological current in the period of the transition from feudalism to capitalism which served as the ideological base to various bourgeois revolutions from the 17th up to the 20th century.

7 Later, during the Second World War, after considerably working out their positiosn, the Zionists began to speak of the creation of their own *State* in Palestine.

8 Raphael Patai, *The Complete Diaries of Theodor Herzl*, Herzl Press, N.Y. 1960, Vol. 1, p. 42.

9 *Jewish Chronicle,* Aug. 28, 1903, Supplement, p. xii.

10 Edward Glick, *The Triangular Connection: America, Israel and American Jews,* George Allen and Unwin Ltd., London, 1982, p. 105.

11 Roberta Feuerlicht, *The Fate of Jews: A People Torn Between Israeli Power and Jewish Ethics,* Times Books, N.Y., 1983, p. 4.

MAXIME RODINSON
from "Nation and Ideology" in
Cult, Ghetto and State:
The Persistence of the Jewish Question

{The identification of nationalism and ideology as identical here limits the discussion to an examination of nationalism as an expression of the theoretical justification for an already existing institutional format, be it a State formation or the prevailing hierarchy.

The differentiation between the nation as a People as opposed to a State institution is fundamental to any precise consideration of the issue and yet, it is rarely invoked. The same situation continues to be maintained in this contribution of Maxime Rodinson whose linear conception of "ethnic-national ideologies" and then state structures leads him to believe in nationalism as a myth. The lack of distinction between ideology and nationalism overlooks the deeply rooted political culture associated with a people's culture in general which has formulated a way of thinking and a manner of expression; a consciousness. This collective consciousness denies the supremacy of socio-economic class orientations which are oftentimes thought to be fundamental to all forms of consciousness notwithstanding the long held proposition for the abolition of class segregations.

Rodinson's criticism of nationalist consciousness is based on the assumption that conflict is inevitably generated by this "ideology" and its drive to construct a competitive state formation. However no consideration is given to the mutual recognition and respect being proclaimed throughout the world by one nation for another and the mutual aid this engenders. This then comprises the concept of internationalism as opposed to universalism. Without such a recognition we would have to reduce social existence to a Hobbesian nightmare of a war of each against all.- e.W.}

'People', 'ethnic group', 'nationality' and 'nation' are different terms designating various types of aggregate formations whose scope goes beyond and transcends that of the primary aggregate groups: clans, tribes, cities and villages, city-states, provinces. All of them suggest the rise of bonds of solidarity that unite these ethnic, territorial or simultaneously ethnic and territorial groups. There is no

agreement about the different types of formation to which these labels should be applied. The important point is to understand that there is an infinite gradation of forms, and the criteria of differentiation are multiple.

Any group of this type will have, at a minimum, a vague consciousness of itself, an implicit ideology that corresponds to its perception of reality and responds (more or less well) to the exigencies of its conditions. Intellectuals, albeit sometimes of a very primitive sort, develop more or less elaborate theories, and thus make these basic ideological elements explicit, warping them somewhat in the process. At the very least, the ethnic-national group is defined, set off from others. The cultural features and institutions that constitute, or are supposed to constitute, its specificity are thus welded to its identity. All its manifestations of unity are thereby justified and legitimated.

All these various ideologies, however much or little explicit and theorized, may be called ethnic-national ideologies. The more specific term 'nationalism' has generally been applied either to the ideology of the nation-state in its contemporary form or to the most highly theoretical, most aggressive (and also most detached from any other reference point) versions of this ideology produced by the various ethnic-national groups.

1. Ethnic-National Ideologies and Formations

Ethnic-national ideologies vary first of all, of course, according to the sort of group to which they correspond.

Unorganized ethnic groups are unstructured, or ill-structured, sets of practically independent units like tribes or city-states. Examples would be the tribes of Gaul, the Germanic, Israelite, or Arab tribes, the Sumerian, Greek or Mayan city-states, the Egyptian nomes of the pre-dynastic age. These units, the members of which speak the same language and have many cultural features in common, acknowledge a kinship system on the pattern of the clan or family. There are often institutions that serve to manifest this very relative unity, at least at certain intervals. Examples are amphictyonies, pilgrimages to a common sanctuary, fairs or common markets, sport or literary competitions like the Olympic Games or the pre-Islamic Arab market of 'Okaz.

Ethnic-national states emerge when a state structure is formed encompassing a given ethnic group or significant part of it. Political unity may then level internal differentiations to a certain extent,

depending on the strength of the state and the degree of integration permitted by economic and geographic conditions. Ethnic-national ideology is then reinforced and becomes state ideology. This is what happened in Pharaonic Egypt, in the ancient kingdoms of Israel, and in the great Chinese kingdoms. Several states may be formed within the same ethnic group, in which case ethnic ideology largely retains the same character as in the previous instance.

Empires are state units within which one ethnic group (in general already grouped into an ethnic-national state, or at least arranged into tribes or federated city-states, as in the case of the Aztecs) dominates others. These are powerful formations which develop an ideology of their own separate from or standing above the ethnic ideologies. If, as sometimes happens, the various ethnic groups tend to fuse within it, then the case of the ethnic-national state re-emerges.

Universalist religious communities likewise normally encompass several ethnic groups in whole or in part. Here again, religious ideology constitutes a serious competitor of ethnic-national ideology.

The dislocation of empires creates ethnic-national *territorial states* corresponding either to fractions of ethnic groups or to more than one ethnic group. In Europe during the latter part of the Middle Ages, powerful monarchies in France and England, supported by rich, influential and dynamic bourgeoisies, created *national* states (or *nation-states*) that encompassed the greater part of an ethnic group whose internal units were almost completely obliterated by the sweep of economic integration. Likewise, the adaptation of the great universalist religious communities to the variety of local conditions and states, sometimes going as far as ideological schism, divides them into *national churches* whose ideology may combine with that of the national state, especially when the latter sets itself in opposition to the universalist community (as in the case of Gallicanism).

In the framework of ethnic-national states, empires or nation-states, *ethnic groups* or *quasi-nations* may subsist or arise, in subordinate positions; depending on the circumstances, they are unified to a greater or lesser extent, more or less integrated into the state, and more or less sensitive to the integrating ideology of the state. They thus constitute ideological minorities of an ethnic-national character, sometimes attached to a religious community (Parsees in India, Jews, etc.), sometimes more or less specialized in some particular social function (smiths, pariahs, etc.) and assuming the character of

castes (blacks in the United States). They may sometimes be reduced to the point of disappearance through fusion, or on the contrary they may become consolidated to the point of demanding secession. Even dependent minority religious communities devoid of any ethnic character of their own, however, may nevertheless often approximate this type of grouping (the various Christian churches of the Middle East, for instance).

During the nineteenth and twentieth centuries, the world-wide predominance of the nation-state (at least as the sort of grouping universally acknowledged as superior), combined with the correlative decay of religious communities as an acceptable kind of suprafunctional grouping, has led to the formation of a *society of nations*. The latter reproduces, at a higher level, the universe of co-existing ethnic groups that prevailed not long ago. The proliferation of international links leads to supra-national aspirations, to the formation of supra-national communities, leagues of nations, federation projects, sometimes to attempts to create empires, like the German National Socialist empire. On the other hand, the formation of a *universalist ideological community*, the Communist world, which at a certain point approximated (at the least) the imperial type, reproduces the past dynamic of the constitution and dislocation of empires and churches, which ideological schisms, the consolidation of nation-states not fully integrated into the empire, and aspirations for the formation of nation-states on the part of politically integrated ethnic groups or nationalities. The complexity of these various formations demonstrates that a *plurality of possible frameworks* may exist for the same individual or the same group. One may belong simultaneously to two formations, to two different levels.

2. Orientations and Structure of Ethnic-National Ideologies
Orientations Depending on Conditions

An ethnic-national ideology can be understood only as an overarching orientation that leaves its mark on all elements of the structure of that ideology. In sum, this orientation constitutes the relationship between the situation in which the group finds itself and the aspirations of its members, depending on the possibilities, real or imagined, of satisfying these aspirations. Normally, ethnic-national ideologies are *ideologies of affirmation* that simply lend an ideological form to consciousness of relative unity. From this angle, they represent 'ideological' ideologies in the strict sense, according to the classification proposed by Karl Mannheim -- in other words, they

simply transcend the real situation of the group, embellishing, mystifying, and mythifying it, without genuinely seeking to realize the ideal thus portrayed. But the affirmation slackens or is intensified depending on the circumstances, essentially as a function of internal tensions between groups, as well as threats or attractions from outside. Powerful tension between internal groups can lead in practice to disdain for the ethnic-national unit, and more rarely to a challenge to it at the level of theory. It is more facile to denounce the enemy groups as betraying the ideal behavior of the ethnic group. Sharp and lasting conflicts between neighbouring ethnic groups can lead to *ideologies of competition or combat,* to mobilizing ideologies. Apologetic myths and others disparaging the opposed ethnic groups then proliferate. The gods of both sides are drafted into service, and simultaneously exalted or disparaged...

If an ethnic group normally unified (or at least federated) by a state embarks on an imperialist policy, dominates or strives to dominate other ethnic groups, an *ideology of domination* arises. The reign of this dominant ethnic group is identified with cosmic order, its mores and institutions with the realization of the human ideal itself. Those who resist are denounced as rebels against universal order and are consigned to the category of the sub-human, the bestial, and associated with the disorder of the elements at the time of primeval chaos, with the precultural unreasoning vagaries of pure nature. Once again, these are 'ideological' ideologies in Mannheim's sense. *Ideologies of resistance* are formed in opposition to these efforts at domination, and if the domination is an accomplished fact, these may become intensely mobilizing *ideologies of revolt.* Insistence is then placed on ethnic loyalty, on fidelity to the national values and gods, against the putative or real dominators, and above all against any forces within the ethnic group itself that opt for 'collaboration'. Beyond that, an entire ideology of national independence, of liberty, denounces oppression and tyranny in themselves, as well as the cruelty and dissolute morals that are assumed to be intrinsic to the dominating ethnic group, and the luxury they draw from their pillage. Sometimes this ideology may even go beyond the ethnic horizon. An appeal for solidarity from other threatened ethnic groups is then issued, and an underlying unity may even be postulated. The Celts and Germans against the Romans, for example. Now it is a matter of what Mannheim calls 'utopian' ideologies, which transcend the real situation of the group and trace the portrait of an ideal situation which the people are called upon to realize through action. If repeated experience persuades people that revolt or resistance is futile, then

ideologies of resignation, submission, or even *renunciation* may arise. Submission is often extolled in encomiums to the conquering nation, to its virtues, its 'mission', the benefits of the tranquility it establishes, and the values of the civilization it fosters within its empire. If cultural and legal conditions permit, assimilation or integration into this nation is preached...

Alongside these ideologies of submission, and in similar circumstances, *ideologies of renunciation* of the national problem itself may arise: adherence to universalist philosophies or religions.

Levels of Organization and Production of Ideologies

Ethnic-national ideologies are organized and made explicit at various levels. This may occur at the level of the entire society, of the ethnic-national group as a whole. If the latter seeks only to continue to exist and is not subject to dangerous threats, then it will generate conservative 'ideological' ideologies that aggrandize the real situation, or at best paint a portrait of gradual progress. 'Utopian' projects can arise only among poorly integrated groups, or they may grow out of the domain of social struggle, which lies beyond the subject of this article. If, on the contrary, the group is threatened or decides to threaten others, then 'utopian' ideologies of conquest and domination emanate from it.

Ethnic-national ideologies can be the product of *specialized groups* or *classes*, like intellectuals, military officers, or productive workers. To the extent that their ideologies are not adopted by the broader society, these groups constitute a class apart. Soldiers, for example, may produce ideologies of domination in the context of a peaceful society, or workers pacific ideologies in the context of a conquering society (but the opposite can happen too). The ideologies in question can be produced or adopted by *ideological movements* structured into organizations to varying extents. A social or religious movement, for example, may adopt a project of an ethnic-national type by integrating it into the ideological synthesis that motivates it (like early Islam). It can also be a movement essentially devoted to the national cause, and therefore a nationalist movement. We may then be dealing with broad informal movements attracting masses through many competing organizations or even outside them, or a movement may also be composed of a single, well-defined organization, a party. Theories, whether elaborate or not, are the work of intellectuals. The latter quite naturally express not only the point of view of the functional group they represent, but also that of the *class* to which they belong. Nevertheless, two points must not be overlooked. On the

one hand, the material basis, and point of departure of their theories is the sentiment, the implicit ideology, engendered by the general situation of the ethnic group of which they are a part. On the other hand, the theory has a mobilizing function and therefore must respond to the sentiments of the masses of the ethnic group as a whole. These theories therefore cannot be reduced purely and simply to the utilitarian myths of one class of the nation from which they issue, as Marxists too often tend to assume. They succeed only to the extent that they go beyond a narrow class horizon. But the class aspect in which they are garbed cannot be denied either.

Representations

Ideology is a biased representation of the world oriented towards social action. From it are drawn prescriptions of behaviour and action, whether individual or collective. An ideology may leave out of its domain a part of the universe for which objective representations are necessary, determined solely by the necessities of technical action and the possibilities of comprehension of reality, but it often tends to penetrate even this domain. The material for this is drawn for the most part from the objective world, the various elements of the latter being assigned positive or negative labels depending on the general orientation of the ideology and the organizational form that governs its formation. Moreover, extrapolation is the rule, whether it be generalization of real qualities of beings, their multiplication through the proliferation of a abstract or supernatural beings, or the projection of the present into the past or future. There is a constant process of myth-making. The principal actor in the cosmic drama is the ethnic-national group itself, sometimes transposed or incarnated in a human chief or an 'ethnarch' divinity (to use the term and theory of the Emperor Julian). The group is sharply set off from the outside world, and its relations to other groups defined. This is expressed in myths that are most often genealogical, myths of origin. The relations recognized by the ethnic-national units -- and sometimes also the bonds of hostility or alliance, sympathy or antipathy, with neighbouring groups -- are transposed into kinship ties. These myths may also be linked to cosmic myths situating the history of the group within a broader history of the universe, and rendering the group sacred by associating super-human wills with it, thus creating a 'sacred history'. Various groups are ascribed a set of features, a personality, a 'character' of the sort that would normally be attributed to an individual. These features may correspond in part to

observations of real facts. But they are 'essentialist'. They generalized to the entire group traits that may be valid only for some of its members. They eternalized them and ascribe to the members of the group an eternal 'propensity', an immutable essence that they cannot, and never will be able to, shake off.

These judgements are also apologetic. They exalt the group from which they emanate, and identify its norms with those of the human species, in its 'normal', 'healthy', or 'superior' form. The other groups, especially those that are adversaries, are on the contrary disparaged, belittled, and 'diabolized'. Their origin is traced back to sordid incidents (like Moab and Ammon, enemy cousins of Israel whose origin is accounted for by the incest committed by Lot's daughters... Their disagreeable, abnormal, and ultimately even subhuman characteristics are also said to be linked to an essence that they cannot shed.

The competition, conflicts, and struggles of the group with any others tend to be described a as an eternal combat between good and evil. Everything is absorbed into this outlook, and becomes either good or bad; the domain of the neutral tends to contract. In addition, as J. Gabel has convincingly noted, ideological consciousness tends to blur the coordinates of space and time. The successes of the group, and its past glory, are linked to its essence, just as the failures and misdeeds of adversary groups are to theirs. Present national consciousness is projected back into the past. Deviations from the present norm, the differing loyalties of yesteryear, and tendencies towards other forms of association are seen as deviations or monstrosities. All of history is reconstructed as a function of a single project: the constitution of the ethnic-national group as it exists today. At a certain stage, the need is felt to summon up justifications of this representation of the world in the framework of a system of thought broader than the mere ascription of the qualities of the group to the will of its 'ethnarch' god-protector. Secular theories then take shape, like Aristotle's explaining Hellenic superiority by geographical determinism. (*Politics*, vi, 7, 1327b.) Much more recently, appeals have been made to the scientific advances of the nineteenth century in linguistics or anthropology. This has produced racist theories that amount to apologies for a particular nation or set of ethnic-national groups (the Whites, the Anglo-Saxons, etc.). The ideological representations comprise not only myths defining the group and its essence, but also others that delineate the ideal situations that are to serve as its model. These are situated in a mythical

time at either the dawn or the end of history. In either case, a situation is portrayed in which the group -- a free people, strong and happy -- lives in harmony and peace, respected or even served by the others groups, if not identified with humanity as a whole. All tensions, internal or external, are liquidated. If what is involved is an 'ideological' myth in the strict sense, a conservative myth of affirmation, then all are called upon to strive, in their daily behaviour, to approximate this ideal model, generally situated in the past. If this sort of myth has taken on a 'utopian' coloration, then the model is projected into the future, to be realized through political action under the leadership of the authorities of the ethnic-national group, and all are called upon to participate. In organized movements, myths and representations generally take the form of dogmas, of 'theses' to which assent is required on pain of expulsion and accusation of treason...

4. Ethnic-National Ideologies and the World
The Essential Tasks of Ethnic-National Ideologies

Ethnic-national ideologies have a role to play in the essential tasks that are incumbent upon any society. As soon as economic, demographic, geographic, and other conditions make possible a formation of broader scope than the tribe, city, etc., an indispensable mechanism of integration is furnished by these ideologies. At the same time, since any social formation requires some image, some self-consciousness, they provide the ethnic-national group with a functional and operational image adapted to the vital exigencies of this formation. The modes of integration furnished by ideology have been enumerated as follows by E. Lemberg: delimitation from outsiders; affirmation of superiority, especially if the group began in a situation of inferiority; resistance (sometimes offensive) to pressure from outside, to a real or imaginary threat; internal moral structuring through the definition and imposition of a set of values proclaimed as superior to all others; deployment of measures designed to assure the unity and purity of the ethnic-national formation; calls for self-sacrifice, for devotion to it. We may detect here the three principles that Alain Touraine has defined as indispensable to a 'complete social movement': the principle of identity; the principle of opposition (to a given adversary); and the principle of totality, namely reference to higher values, to great ideals theoretically acknowledged by all, to a philosophy or theology claiming to account for the universe as a whole...

When real links, in particular economic ones, between the various infra-ethnic units were relatively lax, ethnic-national ideology was also relatively feeble, exposed to many highly effective competitors, which have been listed above. When the rise of integrated national markets within the framework of ethnic-national states created greater unity, ethnic-national ideology became a powerful force. The bourgeoisie, which participated in this integration in a very special way, became its most ardent defender, though often rivalled in this by the reigning dynasty. With the aid of the latter, the bourgeoisie fought the often cosmopolitan aristocracy, which was wedded to different values, and the religion that was tied to the aristocratic order and tempted by the universalism and individualism of the quest for salvation. The bourgeoisie's demand for a powerful state guaranteeing individual liberty went beyond dynastic legitimation inasmuch as the monarchy was organically tempted by despotism. Hence the appeal, initially confused, to the concept of the sovereign will of the people (which could best be defined within the framework of ethnic-national formations), expressed by the invocation of parliaments or general estates. It was then easy to mobilize the confused sentiments of identity, implicit or latent, of all the members of these formations, and to solicit the allegiance of the lower classes. It was within this perspective that the bourgeoisie created the nation-state.

The Ideology of the Nation-State

This ideology very soon falls under the totalitarian and imperialist temptations often expressed in the term 'nationalism'...The supremacy of ethnic-national ideology, which can henceforth be termed nationalist, was assured by its theorization at the end of the eighteenth century, in connection with the evolution of economic and social conditions and with political circumstances. Christian universalist ideology was losing its grip and the state ideologies their power of attraction as a result of their connection with a social order that had become dysfunctional. Doctrines of the supremacy of the will of the people found welcome reinforcement in their appeal to the profound forces of the popular psyche, so intimately related to the cultural specificities that seemed to delimit both the ethnic-national formations and their linguistic frontiers (language being the most evident of the signs)...

The doctrines of the state as an organic totality demanding the adherence of individuals were drawn together by Rousseau, and more explicitly by Fichte, linked to moral activism...Herder held that

nations are characterized by the original languages in which their real experience is crystallized. It is the vocation of each nation to form a state, which alone can enable it to escape assimilation. The various nationalisms thus lead to a general doctrine of nationalism.

The popularity of this nationalist doctrine has been immense. It served to assure the victory of the bourgeoisie in central, southern and eastern Europe, as well as in Latin America, enabling them to legitimate their power and mobilize the masses of their respective peoples behind them. Later it rendered the same service to the colonial elites, which were thereby able to rid themselves of European domination. Here as elsewhere, the controversy between the advocates of the adoption of a European ideological option grafted onto a different reality and those of spontaneous growth based on local conditions is futile. The European ideological model was adopted because it responded to the exigencies of the circumstances of the Third World in the twentieth century.

Nationalist doctrine was able to be theorized into a conservative ideology, invoking that same fidelity to ethnic-national traditions which, in other circumstances, serves to lead revolt against foreign domination. As we know, it was thus able to become a rampart against revolutionary currents, notably in Europe. In particular, it permitted the fervor born of internal tensions and problems to be diverted towards imperialist expansion. The same process may be observed in the Third World with the contradictions born of the revolutionary use of the same sort of ideology...

The supremacy of ethnic-national ideology thus seems assured for the time being, given the perhaps temporary decline of Marxist universalist ideology, which had been its only serious rival. It has even borrowed the methods of Marxism, as well as some of its doctrines (like that of capitalist imperialism) and a part of its legitimation, through the classic syncretistic procedure of identifying national aims with the humanist aims it had put forward. The concept of imperialism -- in the form of a specific and exclusive characteristic of the European-American capitalist world -- has done great service in this perspective. This supremacy has its theorists and apologists who, going beyond the classical Marxist perspective of the limited and conditional justification of national demands, are developing the idea that the essential quest for identity is the principle mainspring of history, that there is a permanent 'basic principle' (which is the transmutation of the romantic *Volkgeist)*, that a healthy 'nationalitarianism' is profoundly legitimate as opposed to a perverse nationalism or

'ethnism' that demands that the world be divided in accordance with the frontiers of ethnic-national groups, however minuscule, and even when their specific character has been effaced by history. These theories correspond to a particular situation, and are its ideological development.

The theorist of ideologies can only note the capital role played by ethnic-national ideologies during various phases of history, the contingent character of their emergence and of their more or less affirmed supremacy, and their virtues and their vices, not the least of which is to lead to a view of a world in which hostility between groups becomes eternal, with contempt for the interests, aspirations and even the very lives of foreign groups.

from "What is Zionism?"

{Having defined nationalism as ethnic-nation ideology, Rodinson comes to define Zionism as Jewish nationalism. This is, in effect, equivalent to Zionist ideology itself which claims the mantle of the Jewish people as a whole and so claims to represent the interests of theentire people.

The universalist critique offered by Rodinson's intellectualism merely takes advantage of a conjunctural appraisal to conclude that since the Arabs are more disadvantaged at this point, then Arab interests take precedence. Presumably if the situation were to be reversed then so would Rodinson's criticisms, so rendering this perspective analogous to an intellectual balance scale filled with factors based in subjective evaluations. Consequently Maxime Rodinson chooses to conclude:

"Zionism is a very special case of nationalism ...a critique of a purely nationalist type is disarmed before it, (emphasis added, e.W.) a universalist critique, on the contrary, is better-founded intellectually." 1

By using such a self-imposed limitation in methodology which calls itself "universalist" there is no space for an internationalist perspective which in its root meaning is defined as inter-nationalism, "between-nationalisms". Otherwise one would be obliged to conclude that the establishment of the State of Israel was a justifiable, if unfortunate option. This then would lay the basis for the critique

which Rodinson has offered and which defeats itself by the lack of a precision in its consideration of nationalist consciousness.

The particular conception of the Jewish People held by Maxime Rodinson is essentially based upon a religious identification , or a "sentimentalism" as he puts it -- this, in spite of both his own non-religious character and his recognition of the general identification of the Jewish people as Jews without any religious identification being required. - e.W.}

The word 'Zionism' was coined at the end of the nineteenth century to designate a collection of various movements whose common element was their plan to create a spiritual, territorial, or state centre, generally to be located in Palestine, for all the Jews of the world. The success of political Zionism, with its state ambition, assured the priority, even the exclusivity, of this sense of the word. Once its aim was attained, Zionism, an ideological movement of a political type, encountered new problems that have imposed a new definition. Anti-Zionist ideologues, too, have often used the term 'Zionism' in a lax fashion.

For some, Zionism is the product of a permanent national aspiration on the part of all Jews, and for that very reason legitimate and benevolent. For others, it represents an essential betrayal of universalist values, whether those of the Jewish religion, liberal humanism, or proletarian internationalism. For yet others (and sometimes for the same people), it is above all a malevolent produce either of the noxious essence of the Jews or of imperialist capitalism...

1. Sources of the Ideology of Ingathering in Palestine
'Zionism', or Centripetal Tendencies of a Dispersed Group

As a general rule, a group that is held in an inferior position may generate separatist tendencies, alongside demands for equality and the desire for integration, especially, although not exclusively, if it is dissimilar to the ambient society. If such a group is dispersed, the separatist tendency sometimes aspires to the creation of a more or less autonomous centre in some particular territory, a centre endowed with the independence of decision-making conferred by a state structure. We may thus speak of 'Zionism' in the plural...

The formulation of a state project of this kind requires conditions such as a minimum of shared consciousness of identity and regular interchange among local groups (conditions that do not pertain, for example, among the Gypsies).

The tendency in this direction becomes stronger the more the set of people in question is frustrated, harassed, and persecuted. The state project is especially likely to arise among dispersed groups that present more or less the character of an ethnic group and among whom the model of an ethnic state exists, either in their own history or in the example of others. The ideology of modern nationalism, which in general upholds national values as supreme, strongly encourages such an orientation. The situation of American blacks has given rise to several projects of this kind, one of which was realized, Liberia. A minority religious community confined to inferior social positions may formulate identical aspirations, all the more strongly if they exhibit certain common ethnic and cultural features. This was the case among the Muslims of India -- hence the creation of Pakistan.

Any new state created in this way will necessarily encounter the same problems: relations with the diaspora that remains outside the state (which may include opponents of the state project, active or passive); the relationship of the people of this diaspora to the states in which they live; the maintenance within the new state of the special character afforded by its founders...; relations with the indigenous inhabitants when the territory that has been occupied is not empty.

Among the Jews, there were projects of ingathering elsewhere than in Palestine. Herzl himself was for a time attracted by Argentina and by Kenya. For some time the USSR encouraged a Yiddish-speaking Jewish entity in Birobidzhan, which is still officially the 'Jewish autonomous territory'. Judaism was the religion of states in Yemen (in the fifth and sixth centuries) and in southern Russia (the Khazar state, eighth to eleventh centuries).

Palestino-Centric Trends in Jewish History

In ancient times, the attachment of the Israelite or Hebrew ethnic group to its country, Palestine, was quite natural, barely theorized at first. But the internal evolution of the ethnic religion in the kingdom of Judea led, in the seventh century before Christ, to the proclamation of the cult of the ethnarch god Yahveh in the Temple of Jerusalem as the sole legitimate one; this led to the mounting consecration of that city.

The loss of independence of the Hebrew kingdoms of Israel (721 BC) and Judea (587 BC), and the consequent massive deportations to Mesopotamia aroused aspirations of return -- of

political restoration and restoration of the legitimate cult through the reconstruction of the Temple of Jerusalem -- especially among the deportees, who swelled an already numerous emigration. These aspirations were expressed in a religious ideology that emphasized the eternal rights of the people of Israel to Palestinian land, guaranteed by the promises of Yahweh, and prophesied the reconstruction of a new Jerusalem (poetically called 'Zion') in which the Jews (meaning the Judeans), having returned to their homeland, would restore the cult of Yahveh. The ethnic god having acquired universal power through the prophetic movement, all the nations would flock to the holy city, which would become the theatre of the eschatological judgement and of the banquet of joy offered all humanity.

This ideology was later to inspire all subsequent tendencies of more or less similar orientation, notably because of the authority of the texts in which it was expressed, which soon became holy (for the Christians as well, later on: hence the thesis of a 'Zionism of God', the title of a recent book by a Protestant pastor). At the end of the sixth century before Christ, a group of 'Zionist' deportees returned to Palestine with the permission of the Persian kings, rebuilt the Temple, and reconstituted a community faithful to Judaism, a community that was at first autonomous under foreign suzerainty, then independent (from 142 to 63 BC), and finally withered very slowly under the Roman Empire, after the repression of the revolts of the years 70 (marked by the definitive destruction of the Temple) and 135 (from which date the Jews were forbidden access to Jerusalem).

A very numerous diaspora persisted and grew in size. As long as the Temple existed, many Jews acted (though very sporadically) on the biblical recommendation of a pilgrimage to Jerusalem three times a year. As in any emigration, the vicissitudes of the Palestinian metropolis -- struggles, revolts, glories, misfortunes -- were followed with interest, so long as it was the centre of a significant Jewish community (and the seat, until AD 425, of the patriarch, theoretically the spiritual head of all the Jews). In addition, it was held to be holy, as the abode of the ancestors and the theatre of the sacred history of the people of Israel, where many a theophany of Yahveh was located.

The dispersed Jewish communities (religious communities preserving many features of an ethnic group or people) lived under varying conditions depending on time and place, but none that inspired complete satisfaction, for they were almost always subordinate minorities. Their ideological orientations were thus complex and

variable. The 'utopia' of an eschatological restoration of Israel in Palestine (a country generally designated in Hebrew under the name *Eretz Yisrael,* the 'land of Israel') never disappeared. But it engendered only very limited projects in reality: pilgrimage; individual settlement in Palestine to lead a pious life while patiently awaiting the Messiah, who would restore all; at most maintenance or reestablishment of a significant Palestinian community, itself lacking any political project, but capable of providing a spiritual centre for all Jews.

The more prosperous and free, or even endowed with authority, any Jewish community of the diaspora became, the more Palestino-centrism or Palestinotropy waned, although without ever disappearing entirely given the eschatological myth and the special charisma of Palestine guaranteed by the sacred texts. From the second to the seventh century after Christ, for instance, the Babylonian community -- prosperous, enjoying great intellectual and spiritual prestige, living quite peacefully under the authority of an 'exilarch' supposedly descended from David, and recognized and honored by the Persian regime -- competed with Palestine. Judah ben Ezekiel (220-99), a leader of the Babylonian school, declared it a sin to emigrate from Mesopotamia to Palestine before the end of time.

Misery and persecution, on the contrary, tended to encourage Palestino-centrism. Given the weakness of the Jews and the political situation in Palestine, however, people made do with the fervent but passive hope of eschatological restoration, and with the limited projects and actions listed above. Sometimes a false messiah would proclaim that the end of time had come and would lead a small group to Palestine. Theological developments idealized Palestine to the utmost and elaborated a theology of exile *(galut)* . Metaphysical flourishes, like that of the very influential cabalist school of Isaac Luria (1534-72) deprived exile and ingathering alike of any concrete reality, turning them both into cosmic situations.

More realistic Palestino-centric projects arose beginning in the sixteenth century under the combined influence of the massive expulsion of Iberian Jews, the massacre of the Jews of Eastern Europe (1648-58), the mounting secularization of European thought, the speculation of Protestant Christians about the end of time and the role of the Jews according to the Bible, and the great tolerance, and later the decline, of the Ottoman Empire. The Spanish rabbi Berab (1474-1546) unsuccessfully proposed the restoration of a supreme religious authority in Palestine. The Jewish banker

Joseph Nasi, who enjoyed the favor of the Ottoman court, managed to obtain a small district around Tiberias, where towards 1565 he settled some refugees by developing a textile industry from which they drew their livelihood. In the seventeenth century, Shabbatai Zevi, having proclaimed himself the Messiah, tried to inveigle the Jews into an immediate departure for Palestine to await eschatological restoration. But there was no definite political project, whatever the fears of the Ottoman government may have been.

2. The Actualization of the Ideology: Zionism
From Pre-Zionism to Zionism

Aspirations for ingathering -- while they existed among the Jews at least in a latent state, along with others, some linked to Palestino-centric tendencies and some not -- had not paved the way for any realistic political project. The flourishing of colonial projects in Christian Europe beginning in the sixteenth century, combined with the factors already mentioned, gave rise to a welter of plans (primarily among Christians) designed to gather the Jews together either in Palestine or in the Americas, in the interest of some power, or even some individual (the Maurice de Saxe plan, for example). The oldest may have been the project of Isaac de La Peyrere, who in 1642 proposed the colonization of Palestine by converted Jews (like himself) under French aegis. {Some people acted on this idea in 1799, but with no notion of conversion, on the occasion of Bonaparte's expedition to Syria.}

Secular nationalism appeared among the Jews only after 1840, under the influence of the rise of nationalist ideology in Europe. Two rabbis, Yehouda Alkalay (1798-1878) and Zebi Hirsch Kalischer (1795-1874) reinterpreted Jewish eschatology in this sense, while in 1862 Moses Hess (1812-1875), an assimilated socialist Jew, also elaborated a Palestinian project, along resolutely irreligious lines. This trend, which received virtually no support among the Jews, came on top of the plans of the Christian states to divide up the Ottoman Empire, the Protestant missionary effort to convert the Jews, the Jewish or Judeophilic philanthropical schemes, and the millenarian speculations; the result was a proliferation of Palestinian projects. These began to receive the support of a Jewish base of some significance only as a result of the rise of anti-Semitism after 1881, the generalization of the concept of the non-European world as a space available for colonization, and the decline of the Ottoman regime. It was then that the most harassed, most persecuted, and

least assimilated Jewish masses -- those of Eastern Europe, already driven to a fairly massive emigration -- became receptive to such projects, which nevertheless remained a minority option: very few of the emigrants headed for Palestine. It was Theodore Herzl -- coming after less convincing ideological efforts (Pinsker, etc.) and in competition with projects based on purely religious aspirations (the departure of groups ready to await the Millennium in Palestine), secular aspirations to improve the lot of the Jews (agricultural colonies on various sites), or the establishment of a Jewish spiritual or intellectual centre in Palestine -- who finally drafted, in a form that could mobilize, the charter of a secularized Jewish nationalism focused (primarily, but not exclusively) on Palestine.

The Social Causes of Zionism

Leftist tendencies, whether Zionist or anti-Zionist, have generally sought, in accordance with Marxist dogmatism, to legitimate their options by situating their struggle within the framework of a class struggle. The left Zionists emphasize the strength of the Jewish proletarian element and of socialist ideology in the Zionist movement, and suggest that in certain conditions Israel could contribute to the world anti-imperialist movement. Anti-Zionists of the left (and sometimes even of the right) emphasize the bourgeois and capitalist leadership of the movement in the past and its imperialist connections in the present. The common view is of class-based general staffs drafting their plans and mobilizing their troops in order to defend or promote their own interests.

This was a highly varied human group: religious Jews, irreligious Jews who nevertheless wanted to retain some link with their Jewish identity, assimilated Jews interested neither in Judaism nor in Jewishness but nevertheless regarded as Jews by others. Apart from ancestry, all they had in common was precisely this estimation by others. Dispersed, the Jews belonged (unevenly) to various social layers, and to different ones in different places; some were more, some less integrated; sometimes they shared a culture peculiar to the Jews in certain countries (Yiddish-speakers in Eastern Europe); and they were divided by many ideological currents.

Zionism pressed them to choose between projects of integration (or at most of local cultural autonomy), which entailed the adoption of the aspirations and tasks proposed in the various nations, and a separatist nationalist project based on these vestiges of a common history still remaining in their own consciousness and in that of their surroundings. Various factors, both individual and collective,

and quite diverse, encouraged one choice or the other. Many families were divided in this respect. But any reaction of rejection of the ambient milieu fostered the separatist option.

It is nevertheless quite true that membership of a given class could tend to make people lean towards one or another of the available options. Eli Lobel has proposed a subtle analysis of the fluctuating attitudes of various Jewish layers towards Zionism. Here there is insufficient space to summarize it adequately or to add further nuance.

Very schematically, we may say that the movement recruited its rank-and-file troops from the poor and persecuted Jews of Eastern Europe, at least those of them who, while still responsive to the community structures, were inclined towards emigration to Palestine either by religious sentiments or by the sequels of the Palestino-centrist trends described above. The leadership tended to be provided by middle-class intellectuals who sought financial support from the Jewish big bourgeoisie in the West, only too happy to divert from Western Europe and America a wave of lower-class immigrants whose alien ethnic characteristics and revolutionary tendencies endangered their own chances of assimilation.

Zionism, therefore, cannot be considered simply the product of a particular class of Jews. It is true that in order to achieve its ends the movement as a whole sought and obtained the support of various European and American imperialist powers (first Britain, then the United States), and that it also obtained the greater part of its financial support from the most affluent layers of Jews, especially in the United States, who themselves refrained from emigrating to Palestine. It is also true that the excommunication of Zionism by the Communist International drove many Jewish proletarians away for a long time. The tragedy of the situation of the Jews in Europe after 1934, and especially after 1939, on the contrary, won it the support of many Jews of all social layers and all ideological tendencies who had long remained reticent.

3. The Realization of the Zionist Project and Its Consequences
Relations with the Arabs

Initially, Zionism paid very little attention to the fact that the territory it was claiming was occupied by another population, the Arabs. This was understandable at a time when colonization seemed a natural and laudable phenomenon. Nevertheless, some political Zionists, a great authority of spiritual Zionism like Ahad Ha'am, and

many anti-Zionist Jews warned against the problems raised by this fact.

The question became primordial during the period of the British mandate (from the end of the First World War until 1948). The leadership of the Zionist movement shelved the old project of an exclusively Jewish state as an immediate tactical objective, while maintaining it as an ultimate ideal and goal. Tendencies emerged among left Zionists and idealists like Judah Leon Magnes and Martin Buber to retreat to the ideal of a binational Jewish-Arab state in Palestine. Some negotiated with Arab notables. Nevertheless, most Jews found it difficult to renounce freedom of Jewish immigration to Palestine (and they were less and less inclined to renounce it in face of the rise of Nazi anti-Semitism), a point equally difficult to accept for the Arabs, since this immigration, if unchecked, threatened to turn the Jewish minority into a majority and thus to lead to an alienation of the territory.

After the formation of the state of Israel in 1948, the idea of a binational state (in the sense of a state in which Jewish predominance would not be constitutionally guaranteed) was in practice abandoned by the Jewish side. On the Arab side, from about 1967 onwards, the Palestinians raised the idea of a democratic secular state in which Jews and Arabs would be citizens enjoying equality before the law. Most Israelis and their friends, noting the absence from this plan of any effective guarantees for the collective interests of each ethnic-national group, have been suspicious of its sincerity. Moreover, the Palestinian and Arab organizations refuse (at least publicly) to acknowledge the existence of a new Israeli nation. They consider the Jews of Palestine as members of a religious community (hence the insistence on secularism in their program) on the model of the many Middle Eastern communities that coexist within the same state. The exclusively Arab character of Palestine is not in question. Any solution of this kind therefore implies the Arabization of the Western Jews now living in Israel. This is rejected by the immense majority of Israelis, who are committed to a Jewish state of Hebrew language and culture, even by Arabic-speaking Israeli Jews (very numerous now), who are tending, on the contrary, to be Hebraized. Some of those most favourably disposed to Arab grievances (who are not very numerous in any event) would at most resign themselves to a genuine binational state in which the two ethnic-national elements would conserve political structures of their own, with guarantees for the defence of the collective aspirations and interests of both sides.

But Israeli military successes and the absence of any plan of this kind on the Arab side scarcely encourage the development of such an attitude.

Zionist Ideology After the Triumph of Zionism

Political Zionism attained its goal, the creation of a Jewish state in Palestine. This state can now be defended with the usual means of state structures: diplomacy and war. From this some have logically concluded that Zionism, in the strict sense of the word, no longer has any reason for being. Friends of Israel should be called 'pro-Israeli' whether they are Jews or not. David Ben Gurion himself seemed favorably disposed to this thesis. Israeli youth shows little interest in classical Zionist ideology. Some Israeli nationalists may even want to dispose of it and to sever their special ties with those Jews who have chosen to remain in the diaspora, whether or not this attitude is accompanied by the recognition of a legitimate Palestinian nationalism, as it is by the non-conformist member of the Knesset Uri Avneri, who argues for a binational federation.

Nevertheless, a powerful Zionist movement does persist, divided into many ideological currents, especially on the social level. It is a secular Jewish nationalism, although based on a definition of 'Jew' that can admit no criterion but religious affiliation, present or ancestral. It nevertheless continues to insist that Jewry has had a national vocation down through the ages. It strives to reconcile this diagnosis with the desire of most Jews to remain members of other national communities (normally patriotic and possibly even nationalist). Even among very many Jews who reject such nationalism in its theoretical form, it still militates against trends toward assimilation, cultivates all vestiges of special identity, preaches active solidarity with Israel, seeks to mobilize the resources and energies of the Jews in its favor, and indeed makes this a duty, just as it upholds the (highly theoretical) duty of *aliya,* or the emigration of every Jew to Israel. In fact, this is a subject of discussion and dissension, American Jews in particular refusing to acknowledge this individual duty. Their attitude is therefore not easily distinguished from a systematic pro-Israelism scarcely discernible from that of non-Jews.

There is much confusion about all these concepts. In general, anti-Zionist opinion, especially among the Arabs, refuses to distinguish among Israeli patriotism or nationalism, a pro-Israeli attitude, recognition of the legitimate existence of a state of Israel, observation that a new Israeli nation has been formed, and the tradi-

tional Palestino-centric attitude of religious Jews. All this is thrown together in the concept of 'Zionism'. In a more polemical vein, some have gone so far as to characterize as Zionism any defence of the individual rights of Jews, any sympathy for the Jews, or any criticism of the Arab position. Pro-Israeli and genuinely Zionist opinion, on the other hand, also tends to confound these various attitudes, so as to extend to the most contested of them the good name enjoyed by the others.

Consequences of Zionist Success for the 'Jewish Problem'

The Zionist attitude also relies on the success of the movement in its apologia, pointing to its beneficial consequences for the circumstances of the Jews as a whole.

Some of these are undeniable. Israeli economic and military successes have tended to eliminate the traditional image of the Jew as a sickly person incapable of physical effort or constructive vigor and thus cast into either a disembodied intellectualism or sneaky, shady and malodorous activities. The improvement of their image has tended to liquidate certain anxieties, certain complexes of Jews. More concretely, the state of Israel offers a secure refuge for persecuted and harassed Jews (except in the event of a more pronounced concretization of Arab enmity.)

Nevertheless, these are not the only consequences. Once a certain threshold was reached, the Zionist movement, created by a handful of Jews and mobilizing only a minority of them, compelled all Jews to take some attitude to that movement. The creation of the state of Israel has compelled them, *nolens volens,* to take part in problems of Middle Eastern international politics that normally would have been of little interest to them. The dangers the Jews of Palestine have faced, or believe to have faced, have in large part oriented them towards a feeling of solidarity that the Zionist and Israeli authorities have sought to extend and use. From the outset, Zionist propaganda had in any case presented the Zionist option as a duty, as the natural outcome of tendencies latent in all Jews. On many occasions, Israel proclaims itself their representative. The set of Jews has thus tended to appear to others as a grouping of a national type, which seemed to confirm the traditional denunciation of them by anti-Semites.

This has had serious disadvantages, first of all for the Jews of the Arab countries, formerly one Arabic-speaking religious community among others, despised and harassed in the most backward

countries, but not suffering grave problems, for example, in the countries of the Arab East. It was inevitable that in the atmosphere of the Israeli-Arab struggle they would be suspected of complicity with the enemy, and most of them have had to leave their countries. It likewise gave rise to suspicion of Jewish citizens in the Communist states, which had taken a vigorous position in favor of the Arabs. Some politicians have used these new suspicions, along with the inveterate remnants of popular anti-Semitism, for internal political purposes, and in Poland they led to a real recrudescence of organized anti-Semitism.

Quite apart from these cases, in the countries in which the 'Jewish problem' was on the road to liquidation, Jewish identity has been kept alive for many Jews who did not at all desire it: those who believed that a more or less shared ancestry, cultural vestiges that were often very slender and in the process of withering away, and above all a common position as target of anti-Semitic attacks and object of the seductive efforts of Zionism (the former at least declining and the latter often rejected) did not justify membership of a specific community of an ethnic-national type. The consequences of the success of Israel thus strongly impeded efforts at assimilation, which had been on the road to overall success.

Even for the small number of Jews in these countries who were attached only to religious Judaism and sought assimilation on all other levels, this situation led to their communitarian or existential opinion assuming a national coloration, especially since the success of Israel revivified all the ethnic elements of the traditional Jewish religion, turning it away from the universalist tendencies that had also endured since the time of the prophets. Religious Judaism, long opposed to Zionism, rallied to it little by little.

Elements of an Ethical Judgment

All these elements of fact will not suffice to ground an ethical judgement, which inevitably also implies reference to some chosen values. Zionism is a very special case of nationalism. If a critique of a purely nationalist type is disarmed before it, a universalist critique, on the contrary, is better-founded intellectually. By definition, such a critique cannot limit itself to weighing the advantages and disadvantages of Zionism for the Jews. It would primarily emphasize, apart from the general consequences of defining the Jews as a nation, the considerable wrong done to the Arab world by the project implemented by political Zionism centred on Palestine: the alienation of an Arab territory, a cycle of consequences leading to the subordi-

nation and expulsion of a very significant portion of the Palestinian population (it is hard to see how the Zionist project could have succeeded otherwise) and to a national struggle that diverts much of the energy and resources of the Arab world from more constructive tasks, a development that seems to have been inevitable in an epoch of exacerbated nationalisms and of violent struggle against all varieties of colonial enterprise.

Criticism of the methods of Zionism is inoperative and insufficient in itself. Objective analysis can only dismiss both the intemperate idealization of the movement by Zionists and their sympathizers and the no less frenzied 'diabolization' in which their opponents have often indulged. Divided into many divergent branches, the Zionist movement has the normal characteristics of any ideological movement of this type. In particular, they are often reminiscent of those of Communism. The Zionist organizations have employed the usual methods, certain groups and individuals seeking to attain their ends with more scruples than others. Cases of both self-sacrifice and personal exploitation of the ideology can be found, as well as instances of brutality and humanity, examples of totalitarianism based entirely on efficacy and others in which human factors have been taken into account.

Naturally, any universalist critique of nationalism in general also targets Zionism, for in it we find all the unpleasant features of nationalism, beginning with contempt for the rights of others, in a manner declared and cynical by some and masked by others, often transfigured by ideology and thus rendered unconscious among many, disguised in their own eyes by secondary moral justifications.

[1]M. Rodinson, *Cult, Ghetto. and State: The Persistence of the Jewish Question,* Al Saqi Books, London, 1983, p. 150 para. 3

LENNI BRENNER
from *The Iron Wall*

{Choosing to emphasize Lenin's hostility to nationalism, Lenni Brenner's references reveal a contradiction in Lenin's view of the Jewish people in the Russian empire. Here Brenner endorses Lenin's statement that "The Jews in Galicia and in Russia are not a nation" although elsewhere Jews were regarded as a nation, even by Lenin.

The antagonism of the Bolshevik and Menshevik Social Demo-crats toward nationalities served to create the political basis for the Zionist organizations which arose in response to the alienation of the Jewish sub-proletariat. Brenner's blanket support of such sectarian politics is discredited by the failure of the Communist Party to fulfill the expectations it instilled for national self-determination. Likewise the current anti-Zionist critique presented by most Jewish non-Zionists is without influence or significance, particularly in this immediate post-holocaust period. - e.W.}

Marxism and the Bund

Marxism had originally been an affair of Russian language speakers, but the Jewish youth were the first of the oppressed nationalities to adopt it. The workers of the great Jewish slums of Warsaw and other cities of the old kingdom of Poland-Lithuania were the most literate of their class in the empire. Their poverty, their national oppression and the general oppression of Tsarism, made them into natural tinder for the fiery Russian revolutionary movement. The radicalized Jewish intelligentsia, if fluent in either Polish or Russian, usually opted for the wider worlds either language opened up. But all serious socialists realized that propaganda must be in the language of the people, and out of this need arose the *Algemeiner Yiddisher Arbeiterbund in Poiln, Lite un Rusland* - the General Jewish Workers ' League of Poland, Lithuania and Russia - the Bund.

Almost from inception they developed a severe nationalist tinge, proclaiming themselves to be the sole socialist organization for Jews everywhere in the empire. Their comrades in the Russian Social

Democratic Workers' Party welcomed the Jewish workers, but refused to accommodate to the Bund's separatist ideas. Marxism is a guide to revolutionary struggle, and the need for unity compels Marxists to reject anything that unnecessarily divides the workers. When individual Jews spoke the language of the people around them they had no need to join special Jewish groupings. And even a Yiddish propagandist section had to be strictly subordinated to the general struggle. Tsarist Russia had at least 192 nationalities within it and the Okhrana used the traditional antagonisms between these nationalities to divide the workers, pitting Christians against Jews. and Muslim Tatars against the Armenians in the Baku oil-fields. Experience taught Social Democracy to see nationalism as a diversion, an extension of the hyper-literacy of the petty-bourgeoisie, which everywhere drags along the obsolete values and narrowness of the dominant forces in their national societies. Bolsheviks and Mensheviks fully agreed in their diagnosis of Bundism. Georgi Plekhanov, Vladimir Lenin and the other Russians were fully supported by the most outstanding of the socialist Jews, most notably Julius Martov, a former founder of the Bund, and Lev Davidovich Trotsky, both leaders of the younger Mensheviks. They had not the slightest tolerance of Zionism which they saw as obviously petty bourgeois in its appeal. They rarely directly encountered it. Only Trotsky attended a World Zionist Congress, once, in Basle in 1903, when he happened to be in the citly. Zonism had little appeal to Jewish workers beyond the narrowest of 'Jewish' trades, i.e. kosher butchers and the like. But the Bund was a bone in their throats, along with all the other socialist groupings which attempted to combine Marxism and nationalism. It compelled them, most notably Lenin, to scientifically define Marxism, nation, and nationalism.

Lenin is universally recognized as an extraordinary writer; prolific - his collected works run to more then 40 volumes - but rarely even minutely factually wrong. He was possessed with the truth, particularly the realities of social struggle and even bourgeois Jewish scholars often have the highest regard for his name. The Soviet Union has since undergone an immense and often sinister evolution on the Jewish question, as on every other. But none, save the inevitable cranks, even pretend he had the slightest trace of anti-Semitism or hostility towards non-Russians. Indeed, it is said he refused to tolerate even the most harmless ethnic or dialect humour. In power he mercilessly suppressed anti-Semitism, and after the Civil War the capitalist Jewish charities in America co-operated with the

Soviets in the rehabilitation of the ravaged Jewish communities in the Ukraine.

Since our epoch is that of the decline of the venerable empires, perhaps it was inevitable that the struggles of the oppressed nationalities should have given their nationalism a patina of undeserved glory, an illusion invariably shattered by the grim realities of the national states that arose out of the ruins of empire. Lenin never entertained such self-deceptions - for him there could be only one opinion regarding the relationship of Marxism and nationalism:

Marxism cannot be reconciled with nationalism, be it even of the 'most just', 'purest', most refined and civilized brand. In place of all forms of nationalism Marxism advances internationalism, the amalgamation of all nations in the higher unity, a unity that is growing before our eyes with every mile of railway line that is built, with every workers' association ... Combat all national oppression? Yes, of course! Fight for any kind of national development, for 'national culture' in general? - Of course not. The economic development of capitalist society presents us with examples of immature nationalist movements all over the world, examples of the formation of big nations out of a number of small ones, or to the deteriment of some of the small ones, and also examples of the assimilation of nations. The development of nationality in general is the principle of bourgeois nationalism; hence the exclusiveness of bourgeois nationalism, hence the endless national bickering. The proletariat, however, far from undertaking to uphold the national development of every nation, on the contrary, warns the masses against such illusions... The proletariat cannot support any consecration of nationalism.[1]

With world Jewry it was an open and shut case. They did not have a common territory, language or economy, the minimal requirements of nationality. Lenin was contemptuous of Jewish nationalism:

The Jews in Galicia and Russia are not a nation; unfortunately (through no fault of their own but through that of the Purishkeviches), they are still a caste here ... It is ... only Jewish reactionary philistines, who want to turn back the wheel of history, and make it proceed, not from the conditions prevailing in Russia and Galicia to those prevailing in Paris and New York, but in the reverse direction -- only they can clamor against 'assimilation'.[2]

The measure of contempt the Russian Social Democratic Workers' Party had for Zionism was best summed up in the Menshevik Plekhanov's description of the Bundists as 'Zionists with seasickness'. But while he vividly portrayed the national sectarianism of the Bund there was still a huge difference between the two movements. The Bund had no interest whatsoever in Hebrew or

Palestine, which they sneered at as *'dos gepeigerte land'* (land that had died). Their central concept was *'dawkeit'* (hereness). Jews were fully entitled to rights 'here', they should not have to emigrate to America or Palestine to get them.

The Bund not only shared the general Marxist conception of Zionism - a reactionary utopia - but they were the first to experience it as a counter-revolutionary force. Though themselves sectarian nationalists concerning the Yiddish language, they recognized the general need for unity with Polish and Russian workers in both the trade union struggle and the political struggle against the Tsar. They soon encountered a new breed of Zionists who tried to syncretize socialism and Zionism. The *Po'ale Zion* (Workers of Zioin) talked about socialism in Palestine but referred to uniting with non-Jews in the struggle for socialism in Russia as assimilation, 'fighting other people's battles'. Gentile workers would always be anti-Semitic; they denounced the Bund's programme as an illusion, claiming most Jewish workers were not factory proletarians but shop artisans, incapable of waging a real class struggle in the Diaspora. Only in their own state could Jews create a real proletariat from the bottom up. In 1901, the Bund drove the Po'ale Zionists out of their unions, informing them that, since they lived in Pinsk and not Palestine, such talk in Pinsk was objectively class-treason, as the Jewish workers of Pinsk were, quite definitely, engaged in a desperate class struggle with the capitalists and the police.

[1]Hyman Lumer, ed., *Lenin on the Jewish Questions,* pp. 111-112.
[2]*Ibid.,* pp. 111-112.

ALBERT MEMMI
from *Jews and Arabs*

{Albert Memmi, a Tunisian Arabic Jew by origin, provides a lucid defense of the existence of the Jewish people or nation *as such (as opposed to the notion that Jews belong either to a* Jewish religion *or, if secular, to a "universalist" world culture. Jews, Memmi argues, are a people in view of three facts: that they bear a "sense of Jewishness," a sense of peoplehood, are self-conscious as Jews, aside from their participation in a common religion; that their unity is further ensured as victims of a common oppression from "outside" in the form of Anti-Semitism; and that their lives are infused with all the multiplicity of elements of a common culture.*

Memmi therefore proclaims the right of national liberation for the Jews, in the form of Zionism, (As a left Zionist, he favors a socialist mode of government, but places the struggle for socialism as a secondary, post-national struggle.)

What is not considered by this author is a territorial option for Arabic Jews apart from the State of Israel. Not only is this a blind spot in Memmi's thinking, but also it presents a problem with respect to Jews elsewhere. Israel is still presented as the only possible territorial homeland. Perhaps Memmi's dissociation of national and social liberation leads him to such a near-sighted perspective, which leaves aside the choice of national-cultural autonomy and ignores the desire of many Jews who wish to remain in their countries of residence.

Further, he uses the notion of "specificity" of conditions to support his argument for territorial national liberation, based on the notion of the collectivity of the Jewish people. However, the Jewish "specificity" of conditions could also be considered within the framework of the situation of other dominated peoples trapped in a variety of situations in one or more multi-national state, and draw upon the developing international human rights law as it applies to self-determination in its varying degrees ranging from willing assimilation to territorial separation, for a solution of the national problems of Jews wherever they may be.e.W.}

If I were to replace Arabic, which is my mother tongue, with Yiddish, I would find the same ambiguity that is felt by so many Jews

with regard to language, the same intimate separation between a secret mother tongue, still spoken with one's parents but socially ineffectual, and the language of the majority, an impersonal tool but indispensable to one's relationship with others. If we leave aside the couscous of the Tunisians and the gefilte fish of the Poles -- which are savory details, certainly, but were actually adopted to fit the accidental circumstances of the long march -- we find the same Sabbath atmosphere among all devout Jews.

In short, this means that there is *one common Jewish condition* -- common at least to the vast majority of Jews, if not to all. And, of course, common above and beyond the distinctive social features, cultural shadings, historical junctures which give each segment of Jewry its own original physiognomy.

First of all, there are the common threat and risk, which periodically materialize. I have written that it is never easy to be Jewish, that the awareness of being Jewish was never altogether serene. This has been challenged, sometimes hotly, as if I had denied that at the same time there are joys and sources of pride that are uniquely Jewish. However, in my very first book, I described the white tablecloth of the Friday evening, the heady scent of the yellow and white narcissus, the Saturday morning strolls taken amid that extraordinary impression of cosmic peace and that invincible aspiration to universal harmony that every Jew harbors in his heart. I agreed that one could feel some pride in belonging to the people who had given men the Bible, who had laid down the moral foundations of a large part of the world, and who had even survived so many catastrophes; who had, perhaps, gained a remarkable keenness thereby and, oddly enough, unlimited tenderness toward the human species.

Only, I also showed that the Jew paid an unduly high price for these joys, that they existed alongside the menace that never ceased to prowl, even around the capital cities, even inside them; that in this way Jewish anxiety is sustained and honed by the never totally silent echo of the Jews who are being oppressed, robbed, and killed at some point on the globe. Doubtless this misfortune is not always as intense, everywhere, at the same time; doubtless, it varies depending on the hazards of geography and the ups and downs of history; no doubt but what economic success helps the Jew considerably to live; no doubt but what anxiety is tempered or accentuated by the individual temperament: in short, a Jew's dimension as a Jew is not always brought home to him, and a lucky thing it is too. Only, all he need do is think about it, and immediately he feels, alongside the pride, the anguish and the potential threat.

But never mind. I have so often been told that some Jews have never felt that anguish, never been aware of that threat, that I am willing to pretend to believe it, despite the fact that bad faith is sometimes the only possible defense against savage reality.[2] Despite the fact that, even if it were true that individuals manage to forget, to lose sight of the collective destiny, the people taken collectively do not forget: the collective consciousness of *any* of the Jewish communities in the world is always vigilant, never entirely stilled.

It is now time to consider the second characteristic of Jewish existence: being Jewish does not only mean being aware of it; it also means submitting to an *objective condition.* I will come back to this idea; it is vital to this itinerary and to all similar efforts of mine. Being Jewish does not consist only of a set of impressions, feelings, worries, or moments of happiness which one may or may not feel. As if one could say, as you sometimes hear people say, with apparent tranquility: "I don't *feel* very Jewish," and imagine one had settled the matter with a shrug of the shoulders. *Jewishness* is not merely a more or less fleeting way of being -- of the subjective self. Being Jewish is a condition that is *imposed* on every Jew, chiefly from the outside, since it is chiefly the result of the relations between Jews and non-Jews. Now, a Jew can adjust to those relations, he can pretend to see nothing hostile in them, he can claim that he is seldom aware of them, he can even derive special pleasure from them: but he can never forget them for very long except by means of constant ingenuity and painstaking good will.

We naturally find here all of the *objective negativity* of the existence of any oppressed man. For a Jew, it can be summed up in one word: anti-Semitism. Long familiarity with iniquity must not blunt the scandal of it. It must be repeated that the anti-Semitic process is always the same -- from worldly and almost playful denigration, which goes to the trouble of using disguises and finding alibis, to murder. As long as this rejection of Jews remains deep-rooted, I shall never be sure that a given group of men will not, one day, give in to a homicidal rage against Jews. More generally speaking, in fact, I am by no means convinced that the days of genocide are over; we have just had examples of it.

The fact is that we are not dealing only with words and opinions, which could be answered by arguments alone. A famous philosopher, Jean-Paul Sartre, has written that a Jew is a man considered as such by other people. I find that quite inadequate. In my opinion, a Jew is above all a man *treated* as such by other people,

and likely to be still more badly treated. The Jew is not just *accused, maligned,* besmirched unto mythical proportions; he is *genuinely* threatened, set apart, excluded; his life is periodically in danger. Now of course, here again, the weight of oppression is felt to varying degrees: sometimes, as in certain Arab countries, it is institutional and legal, and sometimes, as in Europe, it is diffuse and implicit; sometimes, as only thirty years ago, it reaches paroxysms; sometimes, as we know it today in the big cities, it is shamefaced, almost amiable. But I maintain that it is always there and easy to describe, even in this supposedly civilized universe. I have tried to show how it occurs in the Jew's political life, in his economic life, in his relations with other people's religion, with the dominant culture, etc..

Third and final point: being Jewish is also a *positive* matter of belonging to a group and a culture; it is not only a heavy negative burden.

It is amusing to note that whereas the anxiety and the objective unhappiness are violently denied by the traditionalist circles, the existence of a Jewish cultural tradition and the affirmation of a cultural community are as violently denied by the liberals. Yet those very same liberals strongly -- and rightly -- uphold the cultural liberation of all oppressed peoples, and sometimes even any and every ideological demand those peoples make, no matter how alienating it is. I have often wondered if this moderation on the liberals' part is not due to the fact that many of them are Jewish intellectuals. However that may be, their refusal is possible only as the result of a *misunderstanding* and of blindness to a *fact.*

The *fact* is that the very great majority of Jews throughout the world obviously belong to a culture and a group. The liberals tend to forget too easily how the Jewish masses live, feel, and think. I, naively, used to think you couldn't undertake any just political action without "sticking close to the masses.".....

The *misunderstanding* is over the notion of culture. Sometimes they reduce it to the Jewish religion; and not being devout themselves (which is legitimate), they eliminate the problem by crossing it out on paper (which is frivolous), in a cultural universe where religion still governs the existence of the majority. Sometimes, with false humility, they admit their ignorance of the traditional texts, the Bible, the Talmud, the Zohar, and conclude that they do not participate in that culture in any way -- if that culture exists, if it is not already dead and buried. The reason is that, for them, culture is chiefly a set of texts. Now, the culture of a people is not only a matter of books; it is

a dense baroque monument of institutions, rites, collective habits, mental attitudes. It is possible for a Jew never to have seen a copy of the Zohar, or not to know that there are two Talmuds; yet he belongs to the Jewish culture because he buries his dead in a certain way and rejoices in his way when a child is born -- both cultural traits, like the wedding ceremonies and the culinary ritual that those prestigious books, which he has never read, go into in detail. In this outlook, which is infinitely truer and broader than that of our new scribes, virtually every Jew participates -- more or less, of course, as is the case with any kind of participation -- in this common cultural universe. And if he does not, then his brother or his uncle or his cousin does.

As with any aspect, even the most positive, of a dominated man's behavior, there is another side to the coin that I find equally important: being Jewish also means *not belonging* to the same culture as other people. I like to offer this simple example: even in the West, the societies in which we live are fundamentally religious, even though they may be secular on the surface. People's lives move to the rhythm of the major religious holidays, which provide the occasions for collective communion. This is normal and legitimate. It would be surprising if a group's religion, having impregnated for so long its entire life, did not also extend to its institutions. There is nothing scandalous about a majority spontaneously imposing its nostalgia, its joys, and its mourning. Only, the Jew, like any minority member, is relatively excluded from the collective memory, the deep-rooted cultural heritage. Now of course he can get used to this, he can even derive some pride from his solitude, which has perhaps some nobility to it. I simply note the result: a sort of constant hiatus between the Jewish citizen's public life and his private life. When the nation of which he is part celebrates Easter, he must stop work; when his own holiday, Passover, comes, he does not always have the right not to work. In other words, being Jewish also means *not* taking part completely in the dominant culture, not going to the same place of worship as one's fellow citizens, not living to the beat of the same collective rhythm, not always reacting with the same sensitivity, and it also means all the practical consequences that these things imply. Above and beyond its positiveness, and perhaps because of that very positiveness, a Jewish existence is always burdened with a heavy negative coefficient. This, as I have amply shown, is one of the clearest signs of oppression...

We must come back to this fundamental point: *the Jewish condition is an objective condition.* Being Jewish is not just a matter of being devout or not, being attached to certain ethical values or

not; it does not merely mean being considered a Jew by other people; affirming or rejecting oneself as a Jew does not change matters much. Being Jewish means to *undergo the destiny of a single group of men.*

This means that it is not merely a question of opinion but also a set of facts, traits, behavior patterns, and even of types of treatment undergone. Consequently, if this condition is to be transformed, it will never be enough to tackle the opinions held on either side, by Jews and non-Jews, that *will have to be changed completely.*

Therefore I examined, chiefly, two attempts at solutions, both of which ended in failure: dialogue with the political left, and dialogue with the Christians. In both cases, the concrete Jewish condition, the living Jew, are given short shrift in favor of an ideology. The reasoning used by the men on the left proceeds from that open-sesame simplification that they apply to so many problems: let's bring about the revolution, they say, and the Jewish problem will take care of itself. A man I knew when we were both university students breezily maintained, though he was a future psychiatrist, that after the revolution, there would be no more sexually impotent people. This theory does not seem to be borne out by what we know of the U.S.S.R. and the Eastern European people's democracies. More specifically, I have shown that the Marxists, following the example set by Marx himself, apply to the Jewish problem a pattern that is obviously irrelevant; for they persist in understanding it in terms of economics and of class struggle, whereas it is a phenomenon of an altogether different kind.

As for the Christians, for centuries they have stubbornly viewed the problem in terms of theology. That is their language, of course. But at the same time it spares them having to take care of making any concrete transformation in the condition forced upon the Jews. For instance, seriously combating the genuine, and not just metaphysical, racism of their troops. The latest Vatican Council does seem to have turned a new leaf, and naturally this is cause for rejoicing. But that timid step must now be followed by a veritable rush in that direction: recognition of the special social and historical oppression suffered by the Jew throughout the Christian world and the need for ceaseless action to put an end to it.

To tell the truth, neither side has realized, or wanted to realize, the *specificity* of the Jewish problem. This notion of specificity has become one of my most reliable tools in the course of my long inquiry about dominated men... the importance of this notion of specificity is this: *one cannot propose any effective liberation if the specificity of*

each condition has not been grasped. That is why I protested so strongly when attempts were made to reduce the colonial problem first, then the Jewish problem, to a matter of class struggle -- in other words, when you come down to it, to an economic employers-workers pattern. It is reductions such as those that have made the ideology of the political left in Europe impotent...

When, then, is the meaning of the oppression of the Jew? I have demonstrated that the Jews are not oppressed only in the practice of their religion, or only as a religious group; they are not oppressed only as a cultural group; not only in the exercise of their political rights, nor only in their economic activities, etc.. The Jews are oppressed *in every one of their collective dimensions.* In other words, *they are oppressed as a people.*

I know perfectly well that this statement horrifies many Jewish intellectuals, who desperately strive to deny any and all Jewish unity. It is true that such unity is one of the themes in the accusation against Jews and that our intellectuals are -- rightly -- afraid of seeming to strengthen their adversaries' argument. They are afraid that will make them suspect in the eyes of the people in whose midst they live. Not to mention another possible motivation, less noble this time:[3] if they belong to a single people, then there's an end to their "universality" which enables them to look like disinterested judges in all of mankind's causes!

But, here again, we had better look this truth squarely in the face: whether we like it or not, we are looked upon as a special category of foreigners and we are treated as such. Unlike our universalists, the Jewish masses know this and take it into account. The Jewish masses never have more than a limited amount of confidence in their fellow citizens. That is why they constantly confirm their unity, for they know that when a catastrophe occurs, the only help they can hope for will come from the other Jewish communities that have been temporarily spared. People ought to stop stupidly repeating that such solidarity cannot be allowed! That it is a reverse form of racism and other such nonsense. It is a perfectly natural self-defense reaction on the part of an endangered group. Let people stop persecuting the Jews first, and then we will see what they can be reproached with...

Thus, the Jews are oppressed as a people. If we accept the idea that liberation should be achieved on the basis of the *specificity* of each case of oppression, then we are now in a position to take another step forward: *oppressed as a people, it is only as a people*

that the Jews will be genuinely liberated. Today however, the liberation of peoples still retains a *national physiognomy...*

Surely there is no need to repeat that the idea here is not by any means to rehabilitate any given *nationalist doctrine,* postulating the absolute primacy of national identity (which, paradoxically, is what we find today among some of the so-called revolutionary movements), a doctrine making that awareness of identity *a value* superior to all others and, without realizing the contradiction, asserting that the reality of its own nationhood is superior to the reality of all other nationalist movements. A nationalist doctrine of that sort obviously runs counter to all *internationalism.* It is enough that we should recognize awareness of nationhood, denounce all national oppressions, and acknowledge the legitimacy of all national liberations. That would still leave us with the full problem of bringing the various nationalist affirmations into harmony with one another; in other words, the necessity of an *international* set of morals.

Let's summarize, once more, what we believe to be the only accurate interpretation of today's events:

1. *National liberation movements, as such, as progressive, since their intention is to abolish a type of oppression.*

2. *The Arab peoples have begun or are completing their respective national liberations.* And that, as such, seems *legitimate* to us. Just as we found the various decolonizations legitimate, as *national movements.* We did not have to baptize them acts of socialism in order to recognize their justification. It is enough that they enable the peoples to manage freely their own destiny again.

3. *Zionism is likewise the national liberal movement of the Jews.* And we find it equally legitimate. Far from suspecting it, for that reason, far from condemning it as imperialistic, we believe that it ought to be defended, as such, by all the progressives throughout the world. For what is Zionism but the most coherent effort ever made to respond to the oppression suffered by Jews the world over?...

Does this mean that socialism gets short-changed? What is socialism all about?

Let's attempt a definition: socialism is an *ethical* choice, which is made possible by socio-economic analysis and is armed with *political* means.

This ethical choice consists of fighting for social justice within the nation, and political justice between nations. Ultimately, within the nation, it means fighting for the elimination of class differences, if

not of the classes themselves. And, outside the nation, fighting for equality between nations, if not the elimination of nations, which is rather inadequately termed internationalism.

But it is clear that this choice, which is undeniably the most generous and may, in the long run, salvage mankind, cannot be carried out unless the historical, social and even cultural conditions of the groups involved -- classes and nations -- permit it.

NOAM CHOMSKY
from *Peace in the Middle East?*

{This contribution also follows the humanitarian tendency in the Zionist collection or political organizations. By thinking in a manner deferential to the Zionist movement, as if it represented Jewish nationalist aspiration, Noam Chomsky in this following contribution is oblivious to the international context of the issue. The Jewish people who do not reside within the State of Israel, and who are a majority of the Jewish People, are not given any consideration here even though Chomsky himself is one such person. The failure to identify himself as a Jew outside of the Israeli context must be connected to a definition of the Jewish people which rejects a national interpretation. As such, any proposal for a solution to Jewish national aspirations must be limited in its significance.

This particular American Jewish perspective of Chomsky's should be viewed in the context of the needs of the entire world Jewish community. At this current time, it is United States policy not to allow Jewish immigration from the U.S.S.R. despite the freedom granted to Soviet Jews for their emigration. Presently these Jewish refugees are forced to go to Israel despite their wishes. This is of course reminiscent of U.S. and Canadian policy at the conclusion of World War II when Jewish refugees lived in camps while awaiting permission to immigrate to North America. The Zionist program has nothing to offer these Jews, and the State of Israel is not capable of receiving these refugees. The need for a perspective beyond the Israeli framework is pressing and immediate. Unfortunately, it is most likely that the political will appropriate to the crisis will only develop over an unduly lengthy period of time. -e.W.}

These remarks are based on a talk delivered at a forum of the Arab Club of MIT. I am grateful to many Arab and Israeli students for their helpful comments and criticism. From many conversations with them, I feel that they are much closer to one another, in their fundamental aspirations, than they sometimes realize. It is this belief that encourages me to speculate about what may appear to be some rather distant prospects for reconciliation and cooperative effort. There can be few things more sad than the sight of young people who are, perhaps, fated to kill one another because they cannot escape the grip of fetishism and mistrust.

Before discussing the crisis in the Middle East, I would like to mention three other matters. The first has to do with my personal background and involvement in this issue. Secondly, I would like to mention reservations I feel about discussing this topic on a public platform. And finally, I want to stress several factors that limit the significance of anything I have to say. Ordinarily, these matters might be out of place, but in this case I think they are appropriate. They may help the reader to place these comments in a proper context and to take them as they are intended.

To begin with some personal background: I grew up with a deep interest in the revival of Hebrew culture associated with the settlement of Palestine. I found myself on the fringes of the left wing of the Zionist youth movement, never joining because of certain political disagreements, but enormously attracted, emotionally and intellectually, by what I saw as a dramatic effort to create, out of the wreckage of European civilization, some form of libertarian socialism in the Middle East. My sympathies were with those opposed to a Jewish state and concerned with Arab-Jewish cooperation, those who saw the primary issue not as a conflict of Arab and Jewish rights, but in very different terms: as a conflict between a potentially free, collective form of social organization as embodied in the Kibbutz and other socialist institutions on the one hand, and on the other, the autocratic forms of modern social organization, either capitalist or state capitalist, or state socialist on the Soviet model.

In 1947, with the United Nations partition agreement, this point of view became unrealistic, or at least unrelated to the actual drift of events. Prior to that time, it was perhaps not entirely unrealistic. And again, I think, today, this may be a realistic prospect, perhaps the only hope for the Jewish and Arab inhabitants of the old Palestine.

I should say at the outset, that my views have not changed very much since that time. I think that a socialist binationalist position was correct then, and remains so today. Implicit in this judgment are certain factual assumptions regarding the prospects for Arab-Jewish cooperation based on an interpretation of interests along other than national lines. These assumptions are not solidly grounded and are surely open to challenge, as is the implicit value judgment concerning the desirability of a socialist binational community as compared to a sub-division of Palestine into separate Arab and Jewish states or the establishment of a single Jewish or Arab state in the whole region that would preserve no form of communal autonomy. These are the questions that I would like to explore, quite tentatively, and subject to reservations that I will mention.

Returning to my personal experience, the partition plan seemed to me at best a dubious move, and perhaps a catastrophic error. Of course, I shared the general dismay over the subsequent violence and the forcible transfer of populations. A few years later I spent several very happy months working in a Kibbutz and for several years thought very seriously about returning permanently. Some of my closest friends, including several who have had a significant influence on my own thinking over the years, now live in Kibbutzim or elsewhere in Israel, and I retain close connections that are quite separate from any political judgments and attitudes. I mention all of this to make clear that I inevitably view the continuing conflict from a very specific point of view, colored by these personal relationships. Perhaps this personal history distorts my perspective. In any event, it should be understood by the reader.

Let me turn next to certain reservations that I have about discussing the topic at all. These reservations would be less strong in an Israeli context, where my point of view might at least be a reasonable topic for discussion, though it would not be widely shared, I presume. The American context is quite different. In general, the spectrum of political thinking in the United States is skewed sharply to the right as compared with the other Western democracies, of which Israel is essentially one. Interacting with the narrow conservatism that dominates American opinion is an ideological commitment to a perverse kind of "pragmatism" (as its adherents like to call it). This translates into practice as a system of techniques for enforcing the stability of an American-dominated world system within which national societies are to be managed by the rich in cooperation with a "meritocratic elite" that serves the dominant social institutions, the corporations, and the national state that is closely linked to them in its top personnel and conception of the "national interest." In this highly ideological country, where political commitments often border on the fanatic, the question of cooperation in the common interest can barely be raised without serious miscomprehension. Specifically, there is little likelihood of a useful discussion of the possibilities for Arab-Jewish cooperation to build a socialist Palestinian society when the terms are set by the conservative coercive "pragmatism" of American opinion.

It is, furthermore, characteristic of American ethnic minorities that they tend to support the right-wing forces in the national societies to which they often retain a cultural or economic connection. The American Jewish community is no exception. The American Jewish

movement has always been a conservative force within world Zionism, and tended toward maximalist and strong nationalist programs at a time when this was by no means typical of the Palestinian settlement itself...

I suspect that the major contribution that can be made in the United States, or outside the Palestine area, is more indirect. The situation in the Middle East, as elsewhere, might be very different if there were an international left with a strong base in the United States that could provide an alternative framework for thinking and action[1] -- an alternative, that is, to the system of national states which, under the circumstances of the world today, leads to massacre and repression for the weak and probable suicide for the strong. I am thinking of an international movement that could challenge the destructive concept of "national interest" which in practice means the interests of the ruling groups of the various societies of the world and which creates insoluble conflicts over issues that in no way reflect the needs and aspirations of the people of these societies, an international left that could represent humane ideals in the face of the powerful institutions, state and private, that dominate national policy and determine the course of international affairs.

In the specific case of the Palestine problem, such a new framework, I think, is desperately needed, and I can imagine no source from which it might derive other than a revitalized international movement that would stand for the ideals of brotherhood, cooperation, democracy, social and economic development guided by intrinsic, historically evolving needs -- ideals that do belong to the left, or would if it existed in any serious form. Perhaps the most significant contribution that can be made to reconciliation in Palestine by those not directly involved is to work for the creation of an international movement guided by these ideals and committed to a struggle for them, often in opposition to the national states, the national and international private empires, and the elites that govern them.

It is perfectly possible to construct an "Arab case" and a "Jewish case," each having a high degree of plausibility and persuasiveness, each quite simple in its essentials. The Arab case is based on the premise that the great powers imposed a European migration, a national home for the Jews, and finally a Jewish state, in cynical disregard of the wishes of the overwhelming majority of the population,[2] innocent of any charge. The result: hundreds of thousands of Arab refugees in exile, while the "law of return" of the Jewish state confers

citizenship, automatically, on any Jew who chooses to settle in their former homes. The Zionist case relies on the aspirations of a people who suffered two millennia of exile and savage persecution culminating in the most fantastic outburst of collective insanity in human history, on the natural belief that a normal human existence will be possible only in a national home in the land to which they had never lost their ties, and on the extraordinary creativity and courage of those who made the desert bloom. The conflict between these opposing claims was recognized from the start. Arthur Balfour put the matter clearly, as he saw it, in a memorandum of 1919:

... in Palestine we do not propose even to go through the form of consulting the wishes of the present inhabitants of the country, though the American {King-Crane} Commission has been going through the form of asking what they are. The four great powers are committed to Zionism and Zionism, be it right or wrong, good or bad, is rooted in age-long tradition, in present needs, in future hopes, of far profounder import than the desires and prejudices of the 700,000 Arabs who now inhabit that ancient land.3

The Arabs of Palestine may be pardoned for not sharing this sense of the priorities.

Not only can the Arab and Jewish case be formulated with power and persuasiveness; furthermore, each can be plausibly raised to the level of a demand for survival, hence in a sense an absolute demand. To the Israelis, the 1948 war is "the war of liberation." To the Arabs, it is "the war of conquest." Each side sees itself as a genuine national liberation movement. Each is the authentic Vietcong. Formulated within the framework of national survival, these competing claims lead inevitably to an irresoluble conflict. To such a conflict there can be no just solution. Force will prevail. Peace with justice is excluded from the start. Not surprisingly, the image of a crusader state is invoked by men of the most divergent views: Arnold Toynbee, Gamal Abdul Nasser, Itzhak Rabin, and many others.

The likely evolution of the conflict should be particularly evident to the Israelis, given the Jewish historical experience. The exile of the Palestinian Arabs is taking on some of the characteristics of the Jewish Diaspora...Perhaps it is appropriate to recall the warning of Ahad Ha-am, quoted by Moshe Smilansky in expressing his opposition to the Biltmore Program:

In the days of the House of Herod, Palestine was a Jewish State. Such a Jewish State would be poison for our nation and drag it down into the dust.

Our small State would never attain a political power worthy of the name, for it would be but a football between its neighbors, and but exist by diplomatic chicanery and constant submission to whoever was dominant at the time. Thus we should become a small and low people in spiritual servitude, looking with envy towards the mighty fist.4

Parallel comments apply with respect to the Arab states and the Arab liberation movements. There is no possibility that the Jewish population of Israel will give up its cultural autonomy, or freely leave, or abandon a high degree of self-government. Any plan of liberation that aims at these goals will lead to one or another form of massacre, or perhaps to recolonization by the great powers. In this case, too, whatever is of lasting human value in the movement for Arab liberation can hardly survive such policies, and will be submerged in reaction and authoritarianism.

Within the framework of "national interest," of the conflict of "Jewish rights" and "Arab rights," the problem cannot be resolved in terms that satisfy the just aspirations of the people of what was once Palestine.

In principle there is a very different framework of thinking within which the problem of Palestine can be formulated. How realistic it is, I am not competent to judge -- though I might add that I am not too impressed by the "realism" of contemporary ideologists, including many who masquerade as political scientists, historians, or revolutionaries. The alternative is ridiculously simple, and therefore no doubt terribly naive. It draws from one part of the historical experience and the expressed ideals of the Zionist and Arab nationalist movements, from currents that can barely be perceived today, after two decades of intermittent war, but that are nonetheless quite real.

The alternative to the framework of national states, national conflict, and national interest, is cooperation among people who have common interests that are not expressible in national terms, that in general assume class lines. Such alternatives are open to those who believe that the common interest of the great masses of people in Palestine -- and everywhere -- is the construction of a world of democratic communities in which political institutions, as well as the commercial and industrial system as a whole, are under direct popular control, and the resources of modern civilization are directed to the satisfaction of human needs and libertarian values. There is little reason to suppose that these interests are served by a Jewish state, any more than they are served by the states of the Arab world...

A social revolution that would be democratic and socialist, that would move both Arab and Jewish society in these directions, would serve the vital interest of the great majority of the people in Palestine, as elsewhere. At least, this is my personal belief, and a belief that was surely a driving force behind the Jewish settlement of Palestine in the first place. It is quite true, I believe, that "Zionism, being the outcome partly of Jewish and partly of non-Jewish enlightenment, and being also a secular reaction to Jewish assimilation... conceived the Jewish national revival more in terms of the realisation of a harmonious 'just society' than in terms of the realisation of Jewish political independence."[5] Or, to be more exact, this was a major element in the prewar settlement...

If the Arab and the Israeli left are to develop a common program, each will have to extricate itself from a broader national movement in which the goals of social reconstruction are subordinated to the demand for national self-determination. One can imagine a variety of possibilities for binational federation, with parity between partially autonomous communities. A common political and social struggle might take the place of national conflict -- as meaningless, ultimately, as it was to those who slaughtered one another for the glory of the nation at Verdun...

These remarks, I repeat, were made in early 1948. They have a certain relevance to the situation of today. In particular, I think it is important to consider the idea that the only practicable alternative to war is not peace but cooperation -- the active pursuit of peace -- and that cooperation cannot exist in the abstract, but must be directed to the satisfaction of real human needs. In the Middle East, as elsewhere, these needs can be perceived as they are reflected -- caricatured, I believe -- in terms of "national interest." This way, it seems to me, lies tragedy and bitterness. Other ways are open, and they might provide a way to a better life, not only in Palestine, but in every part of this tragic and strife-torn world.

1 For a preliminary effort in this direction see *Eléments, journal of the Comité de la Gauche pour la Paix négociée au Moyen-Orient*, nos. 2-3, May 1969, 15 rue des Minimes, Paris 3°.

2 Population estimates vary. The Esco Foundation study, *Palestine: A Study of Jewish, Arab and British Policies*, (Yale University Press, New Haven, Conn., 1947, vol. 1, p. 321), gives these figures: for 1920, 67,000 Jews out of a population of 673,000; for 1930, 164,796 Jews out of a population of 992,559.

3 Quoted in Christopher Sykes, *Crossroads to Israel*, William Collins, London, 1965.

4 Esco Foundation study, vol. 1, p. 583. The original essay is entitled "The Jewish State and the Jewish Problem," 1987. The 1942 program is generally referred to as the "Biltmore Program."

5 Unpublished lecture by the Israeli scholar Dan Avni-Segré, Oxford, Jan. 1969.

EIBIE WEIZFELD
The Occidental and the Oriental Views on Palestine

Having retained ideological connotations for various world movements such as Islam (and its derivations), Judaism, Christianity and the Rastaferians, Palestine has become a focal point for the exercise of national aspirations and political programs. The significance of this plot of land has become inflated beyond recognition because of competing rivalries. Most notably, the Palestinian scholar Mohammed Adib Aamiry concluded his work on the origins of Jerusalem and Palestine with a quotation from Nahum Goldmann, the former president of the World Jewish Congress and of the World Zionist Organization who is here recorded as saying:

"The Jews might have had Uganda, Madagascar and other places for the establishment of a Jewish Fatherland, but they want absolutely nothing except Palestine; not because the Dead Sea water by evaporation can produce five trillion dollars' worth of metalloids and powdered metal, not because the subsoil of Palestine contains twenty times more petroleum than all the combined reserves of the two Americas, but because Palestine constitutes the veritable centre of world political power, the strategic center for world control." [1]

Although there is no reference given for this quotation, it is none the less plausible that Nahum Goldmann would have made such a statement prior to becoming disillusioned with Zionism and actually dying soon after the 1982 Israeli invasion of Lebanon. Herzl in fact referred to Jerusalem as being needed because of its role "'as an Archimedian point' 104, Patai, Diaries, Vol. III, p. 899." [2] It is also interesting to recognize that the author Aamiry does not dispute the claim of Palestine and Jerusalem being "the strategic center" and by leaving this quotation as the last thought seems to concur in this estimation. Such a position of eminence, though, would be in contradiction to the eminence of Mecca and even the second most esteemed Islamic center. Whether Palestine indeed represents the strategic center for world control or not, it has indeed become the focal point for contestation and battle between the traditionalist Arab and Islamic nations of the Orient against the modernist Occidental power of the Zionist movement in both its Gentile and Jewish dimensions.

The Zionist movement itself is a modernist trend claiming to represent an ancient historical tradition no longer in existence. In the name of this distant past, it has placed itself in opposition to an existing traditional indigenous society in the expectation of successfully negating if not destroying it. As a modernist movement, Zionism is an anomaly because it rejects European modernism, rejecting, on the one hand, European universalism, as it has proved exclusionary to the Jews, and yet paradoxically, affirming universality insofar as it concerns the State of Israel, when it itself is to represent what is universal.

Universality as a concept and means of modern emancipation is a limited item if one considers the context in which it is implemented. The coming into being of bourgeois European nations coincided with the notion that the State and its institutions and instruments of governance were a reflection and embodiment of a single nation or people. In reality, however, most states were in fact multi-national, with the institutions and government a reflection of the dominant nation within them, be it the numerically superior or not. This context rendered the nation-state as a feature of culturism by which universal rights of citizenship are granted to all individual members of a given nation without distinction as to class or gender but not necessarily with respect to nationality. The 1789 revolution, although based on various emancipatory principles, did not extend to the Jews of France. French Jews did not achieve their civil rights until the Napoleonic reforms, which granted them citizenship for opportunistic reasons.

The notion of nation is ambiguious in that the nation-state is assumed to represent only one nation and is for that reason considered to be its equivalent; that is, the nation is supposed to be coincident with the nation-state. Herein lies the agony of many countries which dismiss the existence of national cultures other than the official one, be it majoritarian or not. Majoritarianism, or democracy as it is known, is considered a justification for the most irrational of attitudes towards subordinate nationalities. The fact that the nation-state does not necessarily represent the various nationalities within its confines means the inevitable dissolution of the State, and its uniformity, but not, however, without the likely possibility of the power of the State's military might being turned inward, god-like, against its own citizenry in the attempt to impose a homogeneity cast in its own image (the image of the dominant nationality).

The emancipation offered by the various anti-feudal revolutions (the bourgeois and proletarian) only achieved a transfer of that

centralized power from one strata to another, or even from one class to another, but without the abolition of the power relation itself and with the least advantaged stratae being unable to restrain the means of coercion.

For the Jewish nationality, universalism has been rather ambiguious, because although the Jews have been members of a given nation, they have also been members of their own nationality as well. This dual nationality has not been acceptable to the principle of universality because the concept of universality is based in homogeneity and assumes a certain uniformity. In fact to receive universal rights, it has been and is a requirement, de facto, to become the "universal man," a modernist. For the Jews, this has not really been a matter of choice, since Jews are excluded by definition from the nation in occidental terms by not being from the universal national culture even though Jews are of the nation.

The arch Gentile-Zionist Balfour was quite clear in this respect. For him:

> The Jews were seen as an 'alien and even hostile... Body' whose existence in Western civilization had caused 'age-long miseries', for this civilization could neither expel nor absorb the Body. Balfour declared that on account of their mode of existence and their alienation, the Jews 'loyalty to the State in which they dwell is (to put it mildly) feeble compared to their loyalty to their religion and their race.'[3]

The term "race" common to the previous century is here distinguished from religion, lending itself to be regarded as a substitute for nationality.

Although universality has necessitated the separation of the Church and State in order to safeguard national sovereignty, by arranging a truce between warring sectarian denominations within Christianity, it has not meant that cultural religiosity is separate from the particular notion of the nation. The essence of this separation is the independence of the nation-state from the vertically integrated Catholic Church as it is centered in the Vatican city-state. So the occidental nation is based on Christianity but not the Church per se. This is what is meant by the separation of the church and the State, and although it is a principle in liberal democratic theory, it is not implemented insofar as the universal culture of the Western nation-state is usually accepted or taken for granted as having Christianity as among its determinants.

Given this assumption of cultural homogeneity in the guise of universalism, the Jews as Jews were automatically excluded. Their only recourse has been to assimilate into the dominant culture. This usually proves a temporary accommodation (expected to end in conversion, or otherwise the assimilation is not complete), much like the option presented by the Catholic Church in Spain with the expulsion of the Moors, ending the Golden Age of Jewish and Moorish culture, where conversion or exile was the only choice.[4]

In response to the universalism of the Enlightenment, the Jews have largely fragmented into a spectrum of possibilities which could adapt to the new social environment and thereby achieve the equality offered by universal emancipation or democratic citizenship. Reform Judaism professed its assimilation to the German nation while adhering to a Jewish religion and denying any Jewish nationality. This was a sort of quasi-assimilation based on the presumed separation of religion and nation-state, in line with the modernist context in which it was situated. This movement collapsed because Reform Judaism only masked the perpetuation of an objectively subversive nationality augmented by the Jewish paupers of the East--Poland, Russia and the Balkans-- soon after purged by Hitlerism.

Reform Judaism has had to play the role of the "Marranos", the Jews of the Catholic Spain who maintained a national-religious affinity despite having converted to Catholicism. In both pre-Holocaust Germany and present-day United States of America, the Reform Jews lend their allegiance to the nation-state in exchange for security. This is true for both the Zionist (paradoxically) and non-Zionist wings of Reform Judaism. The basis of such an orientation to the nation-state is the difference seen between religion and national identity. This is a feature of occidental culture which makes a division between secular and sacred life even though these features remain coincident.

Oriental cultures do not seem to consider life-culture to be divided into a secular and a spiritual dimension in the sense that the validity of the latter sphere of life must extend over the former if it has any validity at all. The principle behind Oriental monotheism is that all humans are creations from a common origin, one entity, and so all humans are essentially the same and fundamentally equal. Furthermore there does not exist a hierarchy of divine entitles with different sets of powers reflecting the divisions of a society. The identification of the individual with the single sole deity signifies a certain mutual recognition amongst this set of individuals who then constitute an

identifiable mutually recognized society otherwise known as a nation or nationality. It is not possible to differentiate the nation from the individuals by some religious mechanism since the religion itself is founded on the national concept. This is so since a religion can be founded, but a nation exists.

For Reform Judaism and a political analyst such as Abdelwahab M. Elmessiri in his *The Land of Promise,* to draw a distinction between the Jewish religion and the Jewish people is to adopt the Occidental methodology in order to construct an argument against Zionism. By accepting the Zionist self-definition as being the representative ideology of the Jewish people, and then necessarily opposing Zionism, Elmessiri becomes obliged to oppose the concept of the Jewish people. Elmessiri's definition of the Zionist movement is a consensual position common to both the Arab anti-Zionist current and the Zionist movement itself:

...the present study, a general critique of political Zionism posits a minimum definition of that ideology, namely: It is a belief in Jewish peoplehood in a political sense which endows the Jews, as Jews, with specific political rights in a state of their own. 5

The study provided by Alan R. Taylor, *L'Esprit Sioniste,* also begins with the same premise indicated by the demarcation around the concept, "'Peuple Juif'" 6.

Taylor and Elmessiri each represent variants on the same approach in the Orientalist anti-Zionist critique. Elmessiri points out:

Political Zionism is indebted for its very origin and success to non-Jewish religio-colonialist ideas and forces.....the Christian restorationist movement...(which) viewed the Jew primarily as an instrument in its own scheme of salvation.7

Such an emphasis largely removes the need to consider the powerful forces within the Jewish community which gave rise to an overwhelmingly favourable response to the overture made available by the Christian authorities to attain State power in Palestine. The Zionist response to universality perceived the policy of exclusion from the bourgeois nation (modeled in its own image) and thereby opted to affirm universality in *its* own image as well, calling for auto-emancipation.8 This statist revolution was entirely bourgeois in conception, and in its fundamentals acceptable to the occidental countries for a number of reasons: because it was based upon the

same notions of national-cultural sovereignty, did not challenge the occidental status quo, conformed to the occidental Christian propensity towards the return of the Jews to "Israel" (restorationism) and proposed an exit for an unassimilable population.

Taylor presents a different process which ends up in the same place but for other reasons, for reasons of internal adaptation to modernism:

Jewish modernism spread out and multiplied, comprised of the movement of religious renewal called Reform Judaism; a cosmopolitan and assimilationist current within which a specific Jewish identity is entirely absorbed; the autonomous Jew, the Jewish workers' movement; the Hebrew Renaissance; the colonization of Palestine and Zionism.[9]

Taylor himself points out the logical culmination of the modernist trend (ie. Zionism) in his statement of purpose:

The purpose of our study is the modernist revolution among the Jews. We examine in particular the Zionist movement which ends by constituting a major element of this revolution.[10]

Although they may differ as to the dominant roots of Zionism, both writers favour Reform Judaism's conception of the Jews and its consequent non-Zionism stemming from its non-recognition of the peoplehood of the Jews. Their definition of Zionism as representing the peoplehood of the Jews is adopted from Zionism itself. Their conception of Jews is essentially formed by Zionist methodology. Therefore they are compelled by their rejection of Zionism to reject the idea of Jewish peoplehood. Taylor's modernist currents and Elmessiri's restorationist movement reflect Zionism in that Taylor accepts that Zionism is the logical outcome of these developments he lists -- thus enforcing Zionism and rejecting any means of national liberation other than Zionism, and therefore unconsciously rejecting national liberation for the Jews. Elmessiri, while adding the consciousness of the compelling nature of occidental society in the formation of Zionism, also accepts the Zionist hypothesis by in effect accepting its claim to be the national leadership of the Jews. As a result it becomes convenient to identify with the Reform Judaism's program for Jews: political assimilation and religious identification.

A just and a permanent solution for the Middle East conflict should be based on an awareness of the distinction between Zionism and Judaism.....[11]

The fallacy of the Reform Judaism orientation is illustrated by the split in this formation into Zionist and non-Zionist wings.

The alternative religious formation pointed to as an antidote to Zionism, the ultra-orthodox Chassidim, does not necessarily support the Palestinians. They do, however, present an anti-Statist opposition to Zionism and do not negate the notion of a Jewish people by the use of a religious vocabulary.

The anti-Zionist movement, both Arab and Gentile, so far presents the Palestinian struggle as if it were a reflection of the Zionist program, even denying the existence of the Jewish People as the Zionists deny the Palestinians. They seek to establish a Palestinian State in much the same fashion as did the Zionists with much the same tactics and organizational forms. To the extent that the P.L.O. goes beyond Zionist methodology, it proposes a democratic secular Palestine offering universality (ie. a purely theoretical cultural "neutrality" called modernism)to the Israeli Jews rather than the mutually exclusive Zionist proposition. However this proposal is doomed to rejection because it offers an occidental framework that has already been demonstrated to be impossible, concealing the submergence of dominated nationalities, and is extraneous to the format of an Arabic culture as well. This program is constructed as if the Palestinian anti-Zionist consciousness believes that the expulsion from Palestine was initially successful because of the Zionists' more advanced organizational and methodological frameworks and that in order to defeat Zionism it is necessary to duplicate its methodology. Unfortunately this is very much like the Zionist Jewish reaction to the Occidental countries.

Self-emancipation is not merely a matter of reversing the direction of the course of events. The revolution brought about by Zionism created a transfer of power entailing a land transfer, and a double or triple population transfer (Ashkenazie Jews, Palestinians, and Sephardic Jews). A transfer of power is of itself not liberatory if it remains sectarian. The existence of a central power in a revolutionary transfer remains as a phenomenon merely reorganized to benefit a different exclusive (national) group in society. It becomes necessary to differentiate revolution from liberation. To begin with, the supremacy of the Occidental nation-states must be set aside as an epoch largely in the process of self-destruction, in view of the fact that most are not reflections of single nations, but contain many nationalities, with varying requirements for self-determination. Some nations, such as the African-Americans, are national minorities within a single multi-

national state entity, who may or may not require territorial separation to secure adequate self-determination. Some, like the Kurdish people, exist within the territorial entities of several contiguous nations, and seek either recognition as minorities within those nation-states, or to form a single nation-state entity of their own, Kurdistan. The problems of all such nations beg to be addressed through the wide range of instruments already existent in international law, or plausible to be created and accepted, as grievance-solving devices which further world peace and harmony.

Indeed, the experience of Oriental Jews in the Arab-Islamic world (as opposed to in the Occident) offers a precedent for successful inter-mixing of the two cultures. The idea of a Jewish nation survived though it arose from the ranks of liberated slaves and nomads who began to constitute a nation-tribe without a territory which could be considered visible. Throughout history there have been various means by which a solution has been attempted. The general pattern has been to intersperse oneself-selves amongst existing nations either by force of arms as in the establishment of the original Israel, or generally through a nomadic immigration into various societies. The success of the latter tendency has varied for, while societies in the Middle-East and the Maghreb had found an accomodation with the Jews, the Euoropean societies have carried out purge after purge from one country to another until the Jewish population became imbedded in isolated ghettos where interaction was minimalized with the external nation. At the time of Napoleon's entry in the Egyptian campaign, he made an offer to the Jews of the Arab countries to accept the land of Palestine on behalf of the Napoleonic empire.

Napoleon Bonaparte, the first European invader of the Middle East in modern times, was described by Weizmann as 'the first of the modern non-Jewish Zionists.' 12 In his April 20, 1799, appeal to all the Jews of Asia and Africa, Napoleon had urged them to follow the French command so that the 'pristine splendor' of Jerusalem might be restored. He promised to return the Jews to the 'Holy Land', if they would 'aid his forces'. 13

The crucial point here is that the Oriental Jews refused to consider the matter and fought Napoleon's army alongside their Arab brothers. It should also be mentioned that it was not Napoleon who was the first modern non-Jewish Zionist; it was during the Cromwell period of the Puritans at the time of the English revolution that such

predictions were made.[14] Projections were made for "an Anglican Israel" [15] presumably populated by converted Jews. This theme as it developed came to be pursued by Herzl,

who expressed the hope that the Zionists would reach their 'goal with the aid of the rising Protestant power'. [16]

This Zionist program flowed with the Puritans' fundamentalism to the present day United States of America to become the "8th Crusade".

The Zionist contention that anti-Jewish racism is inevitable and inherent amongst non-Jews generally is contradicted by the Arab/ Islamic experience of Sephardic Jews. The ethnocentric analysis of Ashkenazi Zionism is merely a self-serving attempt to criticize Occidental political culture. With the introduction of the Occidental power and the Jewish community's linkages, including French citizenship, social conditions were exacerbated to the point that around 1962 there was a mass migration of Arab Jews to Israel who had been intimidated by the developing social revolution in response to the introduction of the Occidental social dynamic in Jewish relations with the Arabs. Finding themselves in the "Land of Israel", the Sephardim discovered that far from being welcomed as fellow Jews, as was expected in a Zionist political-culture, Arab Jews were regarded as Oriental. Besides raising a contradiction in the Zionist ideology which claimed to represent all Jews, this alienation with the Ashkenazim exposed the Occidental ground on which Zionism stood. This disunity is expressed in Abba Eban's *Voice of Israel*:

'far from regarding our immigrants from Oriental countries as a bridge toward our integration with the Arabic-speaking world, our objective should be to infuse them with Occidental spirit, rather than allow them to draw us into an unnatural orientalism.'[17]

Modern Occidentalism has not only infused the Jewish people with Zionist ideology but it has also manipulated the Jews to its own interests in the post-bourgeois format of Marxism and Leninism. Another response to modernism was outright conversion in a secular manner in the fashion of the Marx family, which became a feature of Marxism, and included the denial of the existence of a Jewish People, seeking identity rather with a universal proletarian culture. The feature of Marxism which formed an effective critique of univer-

sality in the liberal bourgeois mold pointed to the contradictions of class formations in Occidental society which rendered universal human rights a sham. The proletariat was considered the universal class as opposed to the bourgeoisie in the sense that with the dissolution of all other classes and the assimilation of all members of society into a universal proletariat there would arise an egalitarian society in a broader sense than was conceived by bourgeois universality recognizing the rights of citizens alone. However the class contradiction was not the most fundamental as was thought and within each class there existed national differences and oppressions. Marxist universalism denied the need for the continued existence of nations while regarding the world as the hinterland of Europe. In order to claim leadership of the revolutionary process, Leninism became obliged to recognize the right to self-determination in already existing national formations.

Leninism initially adapted to the Jewish Bund by affirming the right to national self-determination while maintaining the predominance of Jewish workers' identification with class in general. After the Jewish Bund adopted its position in favour of national autonomy in 1901, the "Parti Ouvrier Social-Démocrate Russe" (P.O.S.D.R.), the Marxists, including Lenin accepted by proclamation in 1905 the right of non-Russian peoples to govern themselves thus re-integrating the Bund into the Marxist movement.[18] The substitution of class in general for the nation, however, foundered due to its idealist construction and the cultural realities of the U.S.S.R. society which constructed various republics to accommodate the existing nationalities. The Jews in their Pale of Settlement were nonetheless required to assimilate to the "higher" notion of class although an isolated territory called Birobidjan was later created for the Jews in 1926. Leninism degenerated into Stalinism which regenerated anti-semitism in order to preserve a bureaucratic caste formed from exclusively oriented privileged nationalities in landed republics, and so consequently Zionism dominated Jewish national aspirations for lack of any alternative. In practice, the Bolsheviks betrayed the Jewish people by denying them a territorial homeland in the Pale of Settlement, considering *Jewish* nationalism regressive, and denying the existence of a Jewish People, labeling the very idea petit-bourgeois. The homogeneous concept of universality had again failed the Jews.

A parallel has become established for both the Jews and Palestinians. Both are alienated from their national existence, both seek self-determination, and both have been conditioned by the

prevailing Occidental power. Accordingly, self-determination was adopted as an absolute principle by the Palestinians in opposition to the Zionist claim to self-determination, in order to defeat the greater power by a greater claim to legitimacy over the land. As in the Zionist ideology, the case for self-determination is presented in an absolute manner in order to maintain the demonstration of will considered necessary to win the final objective of the homeland. This ideology is a motivating force in opposition to the inculcated ideology of the occupier. This is not unlike the reaction of the Zionist movement to European racism which adopted the methodology of their oppressors, assuming it was their own deficiency which led to their defeat. And so the Palestinian liberation movement, including the intellectuals who further their liberation, has come to regard the entire conflict from the localized environment, criticizing the Zionist movement itself without evaluating the milieu from which it derives, the Jewish People in the Occident.

From an international perspective, there is a necessary differentiation to be made between Zionism and the Jews, and the Israelis and the Jews. To consider the Jewish people as such with a history of oppression and a consequential right to seek out self-determination seems to contradict opposition to Zionism. It would seem to be a capitulationist position. If a resolution of each situation is to be achieved, then it would seem to be necessary to leave behind the methodology of universalism which, having given rise to Zionism, rests at the center of the impasse. Recognizing the legitimacy of each People's right to self-determination is possible if the Occidental notion of uni-national nation-state is abandoned and in addition if the framework of the discussion becomes extended to a world perspective from the localized conflict. It then becomes possible to conceive of self-determination as a relative right, and not absolute, leading to the mutual accommodation of the Palestinians and the Jews within the territorial entity presently called Palestine by the former, and Israel by the latter.

It is along these lines that Nabil Shaath, Director of the Planning Center of the P.L.O. (Palestine Liberation Organization) in Beirut, Lebanon, defines the Palestinian Charter:

that signifies equally that the exercise by the people of Palestine of their right of self-determination in Palestine does not include the right to exclude the Palestinian Jews from Palestine; that signifies also that this right does not include the right to create in Palestine a State solely Arab. The right to self-determination of the Palestinian People, applied to the Jewish Palestin-

ians, means that they must exercise this right on the land of Palestine, and that this right does not include the right of separation and consequently, the exclusion of the Arab people of Palestine. That is why the right to self-determination of Jews and of Arabs in Palestine must be exercised in common on the same land, Palestine ... therefore it is the definitive end of all States within which segregation exists by law or in practice.[19]

In such a parallel non-exclusive and reciprocal manner, a break-through is achieved. Similarly, the same method applied in the context of the latter point, of a world perspective, it is possible to conceive of an internationalism, reciprocal and so, non-exclusionary. Such an internationalism is rooted in its derivative meaning of inter-nationalism, or between nationalisms (an agreement between nation-alisms). By this manner, the Jewish people can achieve recognition and self-determination without becoming dependent upon abstract land claims sponsored by other interested parties.

Reciprocity as a concept would also be appropriate to be consid-ered as the context for international relations between the Orient and the Occident in all spheres of life, including economic, political and cultural.

1 Mohammed Adib Aamiry, *Jerusalem: Arab Origins and Heritage*, Longman Group Ltd., London, 1978, Page 52.

2 Adelwahab M. Elmessiri, *The Land of Promise,* North American, New Brun-swick, New Jersey, 1977, p. xv.

3 Elmessiri, *Op cit.*, p. 92

4 Notably, the Moorish and Arab Islamic culture in general has provided a fertile and hospitable site for Jewish existence and development.

5 Elmessiri, *Op cit.*, page xv

6 Alan R. Taylor, *L'esprit Sioniste*, Institute des Etudes Palestiniennes, 1977, page xvi.

7 Elmessiri, *Op cit.*, page 83.

8 Take note of Leo Pinsker's (1821-1891) *Auto-Emancipation,* published in 1882 which, while declaring no affinity for Palestine, nonetheless was adopted by the Zionist movement as it hoped to become the all-embracing national movement of liberation.

9 Taylor, *Op. cit.,* page xiv - xv.

10 Taylor, *Op. cit.,* page xiv.

11 Elmessiri, *Op. cit.,* page 126.

12 *Ibid.* (Letter written, but never sent, by Weizmann to Churchill, cited in Crossman, *A Nation Reborn*, p. 130.)

13 Sokolow, *History of Zionism,* Vol. I, p. 63. The quotation is found in Elmessiri, *Op. cit.,* p. 85 (see also p. 99).

14 Taylor, *Op. cit.,* page 36.
15 Walid Khalidy, "Reappraisal and examination of certain attitudes to the Palestine Problem," *Middle East Forum,* Summer 1958, page 22.
16 Patai, *Diaries,* Vol. III, p. 1186. The quotation is found in Elmessiri, p. 89.
17 Stewart, *Theodor Herzl,* p. 304, found in Elmessiri, *Op.cit.,* p. 115.
18 Taylor, *Op. cit.,* pp. 81-88.
19 Nabil Shaath, "L'autodétermination et l'état democratique de Palestine", pp. 211-218, *Palestine: Actes du colloque Palestine* (Bruxelles, 13-15 mai 1976), Duculot - S.N.E.D., Belgique, 1977, p. 213, translation e. Weizfeld.

CONCLUDING REMARKS

It seems that some would still choose to think that the end of Zionism and its State would also mean the end of the Israeli Jews who would either flee or be driven into the sea. This illusion is the rationale for the attempts over the past period since 1948 to drive the Palestinians into obscurity or into the desert.

Although the ancient Israelis, the Hebrews, lived together with the Canaanites, the Amorites, the Hittites, and Jebusites (the founders of Jerusalem), the Zionist ideology insists upon the myth that these Semitic brothers and sisters did not exist. Of course, they existed during the brief period of the Hebrew Kingdom (some 70 years) and they still do exist. The proximity of the Hebrew and Arabic languages testifies to the similarity in origins. If people choose to cite religious historical writings as a rationale for occupation, then it shall remain to be revealed how the seed of Abraham, who are said to be the inheritors of the Holy Land, does not include the descendents of Ha'jar and Abraham. And if the banishment of Ha'jar and Ishmail at the request of Sarah is considered to be the justification for the expulsion of the Palestinians and appropriation of their lands, then this justification is simply incorrect. How can pretensions of authoritative rabbis declare another people to be inferior when the official rabbis of Europe did nothing to save the Jews under Nazi occupation? Perhaps Nazi rule was considered historically necessary, as are their own powers of destruction.

Lozen zie lieben, azyoy en stininem eins kenen lieben in shulem. The reciprocal principle is indeed operative here. One should only expect those rights which one is willing to grant to others, without prior conditions. This is liberty, and such liberty is peace.

If we acknowledge that our liberty can only be achieved on the basis of knowing the truth, then we must look outside of ourselves to discover what is as real for others as it is for ourselves; then we can know. The mythology of ideological exclusiveness has been found to be the failure of all superpowers. Let us not be lacking in the outsight which is essential to insight. This point is of course as true for non-Jews as it is for Jewish people, and it may surprise some to find a lack of total identity with my own views that are expressed throughout

this anthology. This non-ideological presentation has only one purpose, and that is to offer a manner of thinking that is more true than that which has become the custom. You may benefit of it as you will.

APPENDIX A:

founding statement of the
Alliance of Non-Zionist Jews

A JEWISH ALTERNATIVE TO ZIONISM

The central historic claim made by the Zionist movement since its inception until this very day is that the creation of the Jewish State in Palestine, would provide the only solution to the Jewish Question. Moreover, the left wing of the Zionist movement claimed that the implementation of the Zionist enterprise could lead to the social emancipation of the Jewish workers and farmers, both those in existence and those who would emerge through the creation of the state.

Largely on the basis of these claims, the Zionist movement came to command the allegiance and active support of millions of well-meaning humanitarians, liberals and social democrats, both Jews and non-Jews, throughout the world. The Zionist enterprise has also during its history gained the active support of many powerful institutions, governments, and states which commanded the concrete power to insure the establishment of Israel. In fact, without the support of these, the Zionist enterprise would have remained no more than a utopian fantasy.

Until the holocaust, Zionism had little basis to claim any kind of substantial support among the world-dispersed Jewish population. The historically unparalleled, systematic attempt to physically annihilate the European Jewish population during the Second World War was decisive in their stampede towards Zionism, even though the Zionist leadership refused to fight to open (to Jewish refugees) the doors of even one country--except for Palestine.

In actuality this compliance with the anti-Semitic closed-door policy of Canada, of the US, and of Britain was the logic of their sectarian loyalty to Zionism and so their programme could not serve the life and death needs of the Jewish people.

The establishment of the state of Israel, and the worldwide activities of Zionist institutions and organizations have only now reached a high level of material power and historical maturity. The

time has clearly come to subject these "achievements" to the test of critical analysis and evaluation, from the perspective of those deeply concerned with the liberation and social emancipation of the Jewish people, in particular, and with social progress in general.

It is evident to us that not only has the Zionist movement failed to advance the social goals it claims for its objectives, but moreover its practical effect has been to thwart them. Rather than providing a haven for Jews in Palestine, the Zionist movement has created an historic trap for the Jewish people. The Israeli state now faces a perspective of continued war with peoples increasingly unified and organized, with mounting support throughout the world. The consequences can only be a tragedy, a tragedy which may likely involve the mutual use of tactical nuclear weapons.

What twist of logic considers that the solution to the Jewish question could be realized by the record of the Israeli state? That is:

1. The Israeli leaders have turned their state into a military fortress at war with all the nations surrounding it.

2. The material costs of Israel's war policy have been increasingly loaded onto the backs of Israeli workers (through an inflation rate of about 35 per cent and the mid 1974 devaluation of 43 per cent which has resulted in the current crises) while at the same time a new generation of millionaires has risen to prominence and political power.

3. Israel's "black-skinned" Jews are suffering from oppression and misery in the white dominated social structure.

4. Despite Israel's claim to be democratic, it still has in force a series of emergency regulations imposed in its time by British imperialism and characterized by Zionist leaders at the time as "fascist laws".

5. The Israeli state, since its inception, has been allied with the most reactionary forces on a world scale.

(The Zionist Organization of America can quite correctly state in its open letter to Nixon published in the July 30, 1974 *New York Times* that, "A secure and strong Israel is vital to our country's global interests. Your administration, Mr. President, has consistently recognized this to be true... What was true before October, 1973, remains true today, Israel still remains the only reliable friend and ally of our country in the Middle East. The *de facto* alliance between the United States and Israel remains the firm bedrock of our position in the Eastern Mediterranean.")

6. Israel was and remains a militant supporter of US imperialism in Southeast Asia and was among the first to extend diplomatic recognition to the brutal military dictatorship of Chile.

For the past period, all Jews have been identified with the Israeli state simply because they were Jews. In fact, a Jew who did not identify with the interests of the Israeli state was considered to be a self-hater. We reject the slander of the Zionist establishment which equates critics of Zionism with anti-Semites. We consider the fight against anti-Semitism not to be identical with Zionism. By reducing the role of Jews in the diaspora to that of surrogates for Israel and as such scurrying to cultivate friends in high places, Zionism cuts across the perspective and desire of Jews to combat anti-Semitism in their countries of residence. The present predominance of Zionist thought among Jews is a substitute for the recognition of this necessity and in fact Zionism can be seen as an escapist diversion from fighting anti-Semitism as shown by the fact that Israel's ally, ex-president Nixon, turns out to be an overt anti-Semite (as revealed in the Nixon tapes) and America's highest ranking military officer, General George Brown publicly affirmed anti-Semitism recently.

The reason that critical Jews are considered self-haters is based upon the belief, in Zionist ideology, that all non-Jews are conscious or potential anti-Semites. Thus any solution to the Middle-East crisis that rejects the view that non-Jews are inevitably anti-Semitic but accepts them as potential allies in our struggle against anti-Semitism is labelled as being a rejection of Jewishness. As a consequence of this sectarian attitude towards non-Jews, Zionism removes the need to consider the national rights of the Palestinians and in fact engenders a racist attitude towards Palestinians and Arabs in general. While seeking a path to Jewish self-determination, Zionists have denied that very same right to the Palestinians. In place of the "law of return" for every Jew, we would rather seek a solution for Palestinian self-determination and therefore a solution to the continual war in the Middle-East by supporting the "right to return" for every Palestinian instead.

It is for the purpose of further discussing these evaluations among ourselves and in the community that the endorsers have come together. Although we may not have all the same evaluations as contained in this entire statement we do agree on the general approach to the questions involved. We are all Jews and non-Zionists who generally approach these questions from the point of

view of those within the labor and progressive movements and the intellectual milieu. We include among us participants in a broad range of social struggles, and so we all bring to these particular concerns a deep and abiding interest in human progress and social justice.

Therefore, we are announcing the formation of a public committee whose task will be to bring this crucial discussion to a public platform. Whereas in the past, discussion in Canada of the theory and reality of Zionism has been overwhelmingly weighted in favor of Zionism, the developing contradictions of that point of view and the Mid-east situation, especially after the October War, are demanding and producing critical re-evaluation of the propositions that underlie the status quo. We intend to assist in that process of political clarification and to express a non-Zionist opposition to the policies and missions of the Zionist enterprise.

We urge you to participate with us in this task. [1]

[1] The founding statement of the Alliance of Non-Zionist Jews was first published on November 11, 1974, and has since been reprinted in various newspapers and journals.

APPENDIX B
A Lesson from the Warsaw Ghetto

Today we are commemorating the proud tradition of the historic Warsaw Ghetto uprising because we are indebted to the cultural heritage and determination which it demonstrated. This heroic revolt of our martyrs against anti-semitism and fascism was an indication of their determination to continue the struggle by giving an example to Jews and non-Jews throughout the world. Rather than adopting a defeatist, Massada-type attitude, they sought to gain the attention of the world to drive forward the international struggle against Nazism.

In their fight for liberation, the Warsaw Ghetto Jews heralded the many struggles for self-determination of various oppressed peoples throughout the world. As the Indochina wars have shown, international solidarity is of very great importance to all who suffer oppression. It is an irony of history that now Zionism has put Jews into an alliance with the oppressive forces of US imperialism which oppose the self-determination of many peoples around the world. Among these are the Palestinians who are struggling for their self-determination as well, who number 1.3 million in miserable camps around Israel and further millions under military occupation. This doesn't include the many more who live in a diaspora in various cities in the Mid-East.

How ironic it is that Zionism has placed Jews in a position now where the fascist Menachim Begin, the mass murderer of Palestinians, can come to Toronto to speak for Israeli Jews, and supposedly for all Jews, at the time of the anniversary of the Jewish struggle against fascism. And his speaking as a guest of Canadian Jews on the very anniversary of the massacre of over 200 Palestinian civilians at Dair Yassin in 1948 must be considered an insult to one's self-conception as a Jew.

At present Zionist Jews are placing themselves in the camp of humanity's enemies and isolating themselves in a Massada complex in contrast to the spirit of the Warsaw Ghetto fighters who fought with the positive perspective of a world free from oppression for Jews and all humanity. Jews must look towards a solution to the Mid-East crisis whereby Israelis will live with the Palestinian people in conditions of peace *and* justice.

In dedicating ourselves to help further this goal, we can best carry forward the spirit of what the Warsaw Ghetto Jews fought and died for.

Alliance of Non-Zionist Jews
April 19th, 1975

APPENDIX C:
Jewish People's Liberation Organization
A Declaration

We, the Jews, are a wandering tribe of people who have been seeking a secure right to live in those lands where we reside. It has been written that the Jewish nation is the most oppressed, and judging from the persistence of anti-Jewish prejudice, one has to acknowledge the distinctly historic proportion of that oppression. Never have we been permitted a continuous homeland for more than a few hundred years before another expulsion takes place. Now it seems that the possibility of complete extermination is not out of the question, judging by the degree to which the recent Nazi Holocaust was permitted to proceed. The consequences of such a reactionary demonstration of power have not been concluded, since fascism continues to exist, and the response of a permanent revolutionary wave throughout the world has yet to reach its full proportions.

At the present time, those who seek to establish a power-base for themselves will attack Jewish people while posing as either anti-Zionists, German nationalists or Christians. The manipulations of neo-Nazis and even former Nazis are by no means irrelevant as Western societies have demonstrated how much suffering they are willing to have Jews endure.

Although the Arab nation has largely been removed from the European persecutions, the Zionist settler-colonial organizations have moved into Palestine. Zionism based itself upon the Western need to make its amends while at the same time rejecting the Jewish refugees who could not longer tolerate racism in Europe and Stalinism in the Soviet Union. The realization of Zionism is the fulfillment of the Protestant "restorationist" programme which preceded it. The achievements of Zionism have merely been accomplished through its assimilation to the Western Christian notions of religious militarism with its Crusader attitude towards the Middle East. The Christianized Jewish Zionists pose as the Israelites of ancient times, although the Israelites actually had more in common with their Semitic brothers and sisters than they could with the 52nd state of the U.S.A. called Israel.

The Zionists and the Palestinian Arab people are in a state of war which the Israeli governments seek to perpetuate in order to progressively expel the Palestinians from Palestine. However the Palestinians and the Jewish people are tied together by bonds stronger than war and more than each people realizes. It is not a semantic accident that anti-semitism means both Jews and Arabs are feared and hated in the Occident. The bonds that unite Jews and Arabs in practice extend to the point that the Palestinian struggle should necessarily stand for the liberation of Jews as well. In order to break out of the impasse presented by those who believe that Zionism presented the only recourse for Jewish refugees, and now presents the only refuge for the future, the Jews must be liberated from Zionism.

Although both the Allies and the Zionist leadership presented Palestine as the only avenue for Jews to leave Europe in 1947, the resistance of the Jewish refugees who had survived and lived in the "Displaced Persons" camps resulted in their being permitted to emigrate to North America within the year. Now as well, the Zionist enterprise is not even considered to be a desirable situation by the Israelis who emigrate, outnumbering those who believe their lives will be bettered by going to live in the Israeli state.

It is in the interests of the Palestinian peoples' struggle to support the Jewish struggle against racism so that there will no longer be the apparent need for the only alternative currently presented to help the Jews. To ignore the existence of fascists presenting themselves as anti-Zionists is objectively counter-revolutionary. There will not be a solution to the Palestinian-Arab oppression unless there is an end to Jewish oppression, whether or not this is believed by the Palestinian revolutionary movement. And the same is true in return, whether or not the Jewish people accept that peace will only be achieved with the emancipation of the Palestinians. All else is irrelevant to both peoples.

We shall not be enslaved, made homeless, or murdered when it is so dictated by the whims of ideology, so you hate us whether we may be Jews or Palestinians. Why then should either of us consider the Occidental "World" to be our ally, and the other to be an enemy. We are of the same status, origins and oppressions, and so if we cannot exist in peace then no one, it seems, will be able to, because of the powers which strive for hegemony and ologopolistic economic dictatorship.

A Jewish Alternative to Zionism

Together with the current degeneration into a social existence of perpetual war and war preparation -- named peace -- there grows a dynamic of resistance to war and its corresponding economic stagnation. Despite all the formal rationale designed to perpetuate what is universally abhorred, a Jewish opposition to the Zionist leadership and their followers of both the "left" and the "right" has emerged. This opposition is inevitable as long as we are pushed, educated, trained, ordered, tricked and then led into fighting yet another war, a secular 'Sacrifice of Israel'.

The need and desire for a Jewish territory that is self-determinant -- freed from expulsions and pogroms -- has been led into the fortified ghetto being called Eretz Yisroel but actually operating as the State of Israel under the auspices of the U.S.A..

The territorial solution has been converted into an absolutist religious idea, replacing the routine of ritual prior to the Holocaust, when "god" was seen as the deliverer of his chosen people. With the dissolution of religious practice itself, there emerged territorialist parties based on the surviving religious conviction that *only* in the "Land of Israel" could there be formed a Jewish homeland. Such an idea was encouraged by the Christian States which were refusing entry to the Jewish refugees.

However, the nature of things is that currently a greater proportion of Jews live in lands other than Palestine: in North America, Europe, the U.S.S.R., South America, the Near East, the Middle East, China and elsewhere. In fact less than 30 percent of the world's 14+ million Jews live under the State of Israel. The fundamental premise of Zionist theory has in practice been ignored or rejected consciously by the greater proportion of all Jews, who are non-Zionists. Israel is not the sole legitimate homeland of the Jewish people.

The Jewish nationality exists within and without the Israeli State. The non-Israeli Jews live within an illusion of assimilation oftentimes sugar-coated in Zionist acquiescence or pretension. While the territorialist yearnings of Jews to form a nation is currently sifted into the Zionist pot, the territorial need should actually be met in those areas where Jews themselves reside, where our rights as citizens must and shall be met to truly satisfy our social existence. This is self-determination for all Jews rather than the pseudo-independence of Israelis alone.

Presently Zionism negates the very principle of self-determination, which it itself claims to represent, by submerging the

Palestinian people below the struggle for universal auto-determination, the only common definition for freedom. One's right to self-determination is predicated upon the respect one holds for that very same right as it is held up by others. One's principled needs cannot be fulfilled unless such a right is to be upheld for all others as well, as a principle, forging a solidarity through which others become allies on the basis of reciprocal rights. In this way are our needs to be ensured, not by militarism. In this way, one reaches "a land without a people for a people without a land"* and not by means of the Israeli-supervised Sabra-Shatila massacre -- a pogrom which has ended the illusions of all who are not deluded. An historic turning point has been passed. Let it be universally acknowledged, as it is by the Director of the Planning Centre of the P.L.O. in Beirut, Lebanon (Nabil Shaath), that the Palestinian Charter:

signifies equally, that the exercise by the people of Palestine of their right of self-determination in Palestine does not include the right to exclude the palestinian Jews from Palestine, that signifies also that this right does not include the right to create in Palestine a State solely arab. The right to self-determination of the Palestinian People, applied to the jewish Palestinians, means that they must exercise this right on the land of Palestine, and that this right does not include the right of separation and consequently, the exclusion of the Arab people of Palestine. This is why the right to self-determination of Jews and of Arabs in Palestine must be exercised in common on the same land, Palestine.**

The principle of reciprocity is thereby acknowledged: "that signifies the end of all States which require that the self-determination of its ethnic group assumes the exclusion of another ethnic group... it is thus the definitive end of all States in which segregation exists de jure or de facto." According to tradition, the Palestinian People are the Jewish People's second sisters and brothers, and it should be understood that the respect given to another is the measure of the respect to be expected, in any recip-rocal manner of living. We should acknowledge that the Palestinian tradition parallels the Jewish history in duration and intensity.

The one comprehensive solution presented, of an all-inclusive, pluralistic Palestine, is the one and sole alternative to civil war; that is, poly-national in scope including all the Palestinians, resident Jews and the Druze. The method of resolution available is an international conference of all concerned parties, this being an immediate necessity and possibility.

Independence and Territoriality

The State of Israel of 1948 was not the unique first attempt to initiate a modern Jewish homeland or territory; the first attempts being in the Pale of Settlement and in 1926 at Birobidjan in the U.S.S.R.. A Jewish Land failed to materialize from the Bolshevik revolution as the Leninist promise to the Bund in 1905 was broken. These attempts have failed the test of viability and Jews have continued to desire those features of life unavailable to them in prevailing societies: that is, the need for autonomous or independent territories (in conjunction with autonomous existing urban national-cultural settings). This need for territories is evident in the worship from afar politics of the various communities towards the Israeli State, a desire which is based on the real needs for land, security, peace and the freedom of identity and culture historically denied the Jews. Existing societies do not provide for these material necessities, and existing political doctrines do not consider Jewish needs. Jewish territorialism should not and need not mean the abandonment of traditional Jewish opposition to political power and Statism, since a Jewish Land should reflect a Jewish political culture.

In this aftermath of the Nazi Holocaust, no one should deny the hostility of prevailing Occidental societies as none of the participants or spectators in that war of genocide have undergone a substantial transformation. Likewise, the Zionist establishment follows in the footsteps of power politics. How bizarre it is that a stockpile of some 200 genocidal nuclear bombs has been accumulated by a State professing peaceful intentions with a Jericho intermediate-range missile.

Should anti-Semitism be permitted to exist because of those who do not believe it is possible to overcome racism? Is this why the Zionists signed the Haavra (Transfer) Agreement with the Third Reich in August 1933, and does this not reveal that those who accept the existence of racism in general accept it also in themselves? Will it be that Zionism will follow in the footsteps of those whom it did not have the will to oppose?

A Jewish Movement

In the tradition of the early nationalist aspirations, the "Bund", and of prior committees in the development of a movement of liberation, the Jewish People's Liberation Organization is based upon the work of the Toronto Alliance of Non-Zionist Jews (1974), the group Canadian Jews Supporting the Palestinians (UN - NGO) -- which

occupied the Israeli Consulate during the first week of the 1982 invasion of Lebanon -- and in addition, the contribution of the periodical *Logik un Sychel.* We are also indebted to the Committee Against the War which publicly protested the 1982 war on its very first day and so inspired the Peace Now movement of 500,000.

The Jewish People's Liberation Organization, a post-Zionist movement, is forming itself to act on behalf of the Jewish and Palestinian Peoples to generate various independent and autonomous national formations in addition to the liberation of Palestine as a contribution to making war unneeded and unwanted. In this struggle we greet the Palestine National Council of the Palestine Liberation Organization as an ally.

January 1, 1988

Corresponding address:

JPLO / OLPJ
c/o La galerie Fokus
68 av. Duluth est
Montréal, Québec H2W 1G8
Canada

* As formulated by Israel Zangwill (1864 - 1926)
** Nabil Shaath, , "L'autodétermination et l'état d´mocratique de Palestine," p. 211-218, *Palestine: Actes du colloque Palestine* (Bruxelles, 13-15 mai 1976), Douclot - S.N.E.D., Belgique, 1977, ISBN 2-8011-0114-1, page 213.

APPENDIX D
Listings of the
Jewish Dissident Movement

Alternative Information Center
14 Koresh Street, "E" Unit
Jerusalem, via Israel

Agenda: That Which Must Be Done
Box 2132, Station D
Ottawa K1P 5W3, Canada

Canadian Jewish Outlook
6184 Ash Street, #3
Vancouver, B.C. V5Z 3G9, Canada

Committee Against the Iron Fist
c/o P.O. Box 20479
Jerusalem, via Israel

Committee to Right Repression
P.O. Box 1435, Cathedral Station
New York, N.Y. 10025, USA

Democratic Front for Peace and Equality
P.O. Box 9410
Haifa, via Israel

International Jewish Peace Union
Box 5672
Berkeley, CA. 94705, USA

International Jewish Peace Union
64 rue Taitbout
F-75009 Paris, France

The Other Israel
P.O.B. 956
Tel Aviv 61008, via Israel

Israeli Council for Israeli-
Palestinian Peace
P.O. Box 956
Tel Aviv, via Israel 61008

Israeli Council for Israeli-
Palestinian Peace
4 Hagilboa Street
Tel Aviv, via Israel

Israel Horizons
150 Fifth Avenue, Suite 911
New York, N.Y. 10011, USA

Israleft
P.O.B. 9013
Jerusalem, via Israel

Israel and Palestine
B.P. 130-10
75463 Paris Cedex 10, France

Khamsin
BM Khamsin
London WC1N 3XX, England

Law in the Service of Man
P.O. Box 1413
Ramallah, West Bank
via Israel

New Outlook
8 Karl Netter Street
Tel Aviv, via Israel

Return
c/o Merav Dvir
BM8999
London WC1N 3XX
England

Return
c/o Bradford Resource Centre
31 Manor Row
Bradford BD1 4P5
England

R.C.L.
P.O. Box 2234
Jerusalem, via Israel

Dr. Israel Shahak
2 Bartenura Street
Jerusalem, via Israel

"Shmate"
Box 4228
Berkeley, CA. 94704, USA

Ernest Kahan, M.D.
P.O. Box 897
Egged Agency
Kfar Sova, via Israel

Youth Bund
25 East 78th Street
New York, N.Y. 10021, USA

"Yocha"
P.O. Box 2093
Haifa, via Israel

APPENDIX E:
Readings

In addition to the works from which selections have been presented, the following make valuable supplemental readings:

Amin, Samir, *Class and Nation: Historically and in the current crisis,* New York: Monthly Review Press, 1980, xi, 292 pp.
_____*La nation arabe:* nationalisme et luttes de classe, Paris: Editions de Minuit, 1976, 156 pp.
Avineri, Shlomo, *Israel and the Palestinians,* New York: St. Martin's Press, 1971, xxiv, 168 pp..
Blant, James M., *The National Question: Decolonising the Theory of Nationalism*
Brenner, Lenni, *Iron Wall: Revisionism From Jabotinsky to Shamir,* London: Zed Books, 1984, 221 pp.
_____*Jews in America Today,* Secaucus, N.J.: L. Stuart, 1986, 370 pp.
_____*Zionism in the age of the dictators,* London: Croom Helm, Westport, Conn.: L. Hill, 1983, 277 pp.
Chomsky, Noam, *The Fateful Triangle: The United States, Israel and the Palestinians,* Boston: South End Press, 1983, 481 pp.
_____ *Peace in the Middle East? Reflections on Justice and Nationhood,* New York: Pantheon Books, 1974, xiviii, 198 pp.
_____*On Power and Ideology: The Managua Lectures,* Boston: South End Press, 1987.
Hecht, Ben, *Perfidy*
Kly, Y. N., *The Anti-Social Contract,* Atlanta: Clarity Press Inc., 1989.
_____*The Black Book: The True Political Philosophy of Malcolm X (El Hajj Malik El Shabazz),* Atlanta: Clarity Press, Inc., 1987
_____*International Law and the Black Minority in the U.S.,* Atlanta: Clarity Press, Inc., 1985.
Leon, Avrum, *The Jewish Question,* New York: Pathfinder Press.
Mehdi, M.T., *Constitutionalism: Western and Middle Eastern,* 1960.
Menuhin, Moshe, *The decadence of Judaism in our time,* Beirut: Institute for Palestine Studies, xxiv, 589 pp., reprint of the 1st ed. 1965, with postscript
_____*Jewish critics of Zionism: a testamentary essay, and the stifling and smearing of a dissenter/Moshe Menuhin,* Detroit: Association of Arab-American Uniersity Graduates, 1976, xv, 64 pp.

_____*Quo vadis Zionist Israel?* Beirut: Institute for Palestine Studies, 1969, Monograph series no. 21.

Porter, Jack Nusan, *Jewish Radicalism: A Selected Anthology,* New York: Grove Press, 1973, liv, 389 pp.

Sarif, Regina, *Non-Jewish Zionism: Its Roots in Western History,* London: Zed Books, 1983, vii., 152 pp.

Turki, Fawez, *Soul in Exile: Lives of a Palestinian Revolutioanry,* New York: Monthly Review Press (available from Jacobin Books, Box 416 Van Brunt Station, Brooklyn, N.Y. 11215).

Weizfeld, eibie, *Sabra & Shatila: A New Auschwitz,* Ottawa: Jerusalem International Publishing House, 1984, 113 pp.

OTHER CLARITY TITLES

International Law and the Black Minority in the U.S.
by Y. N. Kly ISBN: 0-932863-01-9, $15.00
"Kly's unique perspective is worthy of consideration and debate by
minority and non-minority individuals alike..."
 American Journal of International Law

*The Black Book: The True Political Philosophy
of Malcolm X*
by Y. N. Kly ISBN: 0-932863-03-5, $7.95
"*The Black Book* is highly recommended to any serious radical scholar,
militant activist, and most importantly, the Muslim, to understand the
explosiveness and uniqueness of the Islamic revolutionary method
and message."
 Jamalludien Ahmed Hamdulay

The Anti-Social Contract
by Y. N. Kly ISBN: 0-932863-09-4, $8.95
A significant international-legal interpretation of what the social con-
tract concept can mean when applied to minorities trapped in unequal
relations within contemporary multi-national states.

The Invisible Women of Washington
by Diana G. Collier ISBN: 0-932863-02-7, $10.00
"A work of literature, not a leaden exposé of what we should already
know... Collier's novel succeeds to a high degree..."
 The Nation

Dalit: The Black Untouchables of India
by V. T. Rajshekar ISBN: 0-932863-05-1, $7.95
"This book should be compulsory reading for those who wish to under-
stand the true nature of the caste system and the sufferings it causes to
millions."
 Crescent International

Order directly from

CLARITY PRESS, Inc. CLARITY INTERNATIONAL
3277 Roswell Rd. N.E., Ste. 469 P.O. Box 3144
Atlanta, GA. 30305, USA Windsor, Ont. N8N 2M3, Canada

Please include $1.95 handling, plus $0.50 per extra title.